ART QUANTUM

ART QUANTUM

THE EITELJORG FELLOWSHIP FOR NATIVE AMERICAN FINE ART, 2009

Edited by James H. Nottage
with Jennifer Complo McNutt *and* Ashley Holland

Eiteljorg Museum of American Indians and Western Art
Indianapolis

in association with
University of Washington Press
Seattle and London

University of Washington Press
P.O. Box 50096
Seattle, Washington 98145
United States of America
www.washington.edu/uwpress

Eiteljorg Museum of American Indians and Western Art
500 W. Washington Street
Indianapolis, Indiana 46204
United States of America
317.636.9378
www.eiteljorg.org
www.fellowship.eiteljorg.org

Eiteljorg Museum
of American Indians and Western Art

Library of Congress Cataloging-in-Publication Data

Art quantum: the Eiteljorg Fellowship for Native American Fine Art, 2009 /edited by James H. Nottage with Jennifer Complo McNutt and Ashley Holland.
 p. cm.
Issued in connection with an exhibition held Nov. 14, 2009-Feb. 14, 2010, Eiteljorg Museum of American Indians and Western Art, Indianapolis.
Includes bibliographical references.
ISBN 978-0-295-98996-9 (pbk. : alk. paper)
1. Indian art—United States—21st century—Exhibitions. 2. Art, American—21st century—Exhibitions. 3. Indian art—Canada—21st century—Exhibitions. 4. Art, Canadian—21st century—Exhibitions. 5. Eiteljorg Museum of American Indians and Western Art—Funds and scholarships. I. Nottage, James H. II. McNutt, Jennifer Complo. III. Holland, Ashley (Ashley R.), 1983– IV. Eiteljorg Museum of American Indians and Western Art. V. Title: Eiteljorg Fellowship for Native American Fine Art, 2009.
N6538.A4A79 2009
704.03´97007477252—dc22 2009034203

Front cover: Edward Poitras, *Home and Garden* (detail), 2009.
Back cover: Jeffrey Gibson, *Wrapped and Bound* (detail), 2008.
Frontispiece: Faye HeavyShield, *body of land* (detail), 2002–2006.

Unless otherwise cited, all photographs are by Dirk Bakker, Artbook, Huntington Woods, Michigan.

Project management and editorial services:
Suzanne G. Fox, Red Bird Publishing, Inc., Bozeman, Montana

Graphic design:
Carol Beehler, Bethesda, Maryland

Printed in Canada

The paper used in this publication meets the minimum requirements of American National Standard for Information Sciences—Permanence of Paper for Printed Library Materials, ANSI Z39.48-1984.

FORD FOUNDATION

Efroymson Family Fund, a Central Indiana Community Foundation Fund

DBJ Foundation

David Henry Jacobs

Contents

Foreword TURNING POINTS

JOHN VANAUSDALL
*President and Chief
Executive Officer
Eiteljorg Museum of
American Indians
and Western Art*

The sixth presentation of the Eiteljorg Fellowship for Native American Fine Art marks a turning point in the evolution of this project. The Eiteljorg Fellowship has continued to help shape the development of the field, raise awareness and interest in contemporary Native American art, and to recognize and reward the leading artists in the field. New directions are beginning, however, with *Art Quantum.*

At the end of the Fellowship program's fifth iteration—ten calendar years—in 2007, nearly all of the Eiteljorg Fellows from the first five biennials gathered in Indianapolis, along with the writers, scholars, and curators who helped shape the first decade, to discuss the project's future. Among their key ideas for growth and change were to create a far-reaching Web site that would be an important and ongoing gathering place for artists, scholars, and collectors to share art and ideas and to engage in dialogue. The museum launched such a Web site earlier this year and its success has exceeded our wildest dreams (www.fellowship.eiteljorg.org). Second, the Homecoming participants envisioned a major publication, weighty both in mass and in intellectual substance, that would reflect not only the first decade of the Eiteljorg Fellowship, but also would serve as a rigorous and inspiring resource on the current state of the field for contemporary Native American and First Nations art. That publication is under development, thanks to a generous start-up grant from Lilly Endowment, and will be debuted at the 2011 Fellowship gathering. Third, the participants asked that a nationally and perhaps internationally touring exhibition be created to take the Eiteljorg Fellowship collection on the road. They expressed their belief that the project is mature enough, the collection now deep enough, and the audience anxious enough to see it; the time is right for a touring edition. Planning for a major traveling exhibition is underway.

Other minor changes have been initiated, but the project's original purposes and the idea of "fellowship," which is a gathering and exchange of ideas and inspiration, continue. I would like to introduce this year's cohort of artists: Edward Poitras, Jim Denomie, Jeffrey Gibson, Faye HeavyShield, and Wendy Red Star. We thank them for sharing their artistic visions and for subjecting themselves to the rigors of the selection process, curation of the exhibit, and the endless photographs, video taping, and public appearances during the gala week. They are a pleasure to work with. I also want to thank and congratulate Jennifer Complo McNutt, the museum's curator of contemporary art, who has shepherded this project from its inception. She is joined by a consummate professional and rising star, Ashley Holland (Cherokee), assistant curator of contemporary art. Together they have led the program's development and implementation with aplomb. I also want to thank James Nottage for deftly managing this publication and similar catalogues from previous biennials.

From the beginning, Lilly Endowment has provided remarkable financial support for the Eiteljorg Fellowship and continues its generosity and encouragement as we move into the new decade. Lilly Endowment's support of the field through the Eiteljorg Fellowship truly

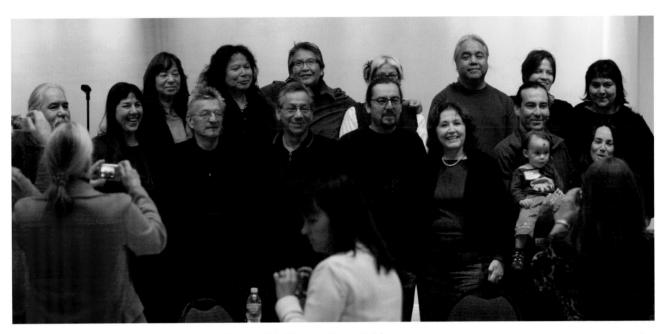

Eiteljorg Fellowship Homecoming, November 2007. Photo by Hulleah Tsinhnahjinnie. Pictured: Joe Feddersen, Nadia Myre, Tanis S'eiltin, Shelley Niro, Hulleah Tsinhnahjinnie, C. Maxx Stevens, James Luna, Marie K. Watt, Sonya Kelliher-Combs, Dana Claxton, Will Wilson, Zoe Wilson, Kay WalkingStick, Gerald Clarke, Truman Lowe, Rick Bartow

places it in a leadership position. Additionally, Ford Foundation has continued to provide support for the Eiteljorg Fellowship through the Illumination project, which has provided major funding to the Eiteljorg Museum and six other cohort members. As the Illumination program winds down, I want to recognize the extraordinary vision and leadership of Betsy Theobald Richards. Betsy's commitment to furthering Native American arts, her brilliant idea to create the seven-member cohort, and her tenacity in funding and shaping the program have made a lasting mark on the field. Support from the National Endowment for the Arts makes this catalogue and other printed materials for Fellowship possible. Finally, I want to give special thanks to the Efroymson Family Fund, a Central Indiana Community Foundation Fund, and to David Henry Jacobs for supporting this important project. The artists, scholars, museum staff, and others are grateful for the support of these organizations. ∎

EFNAFA
Eiteljorg Fellowship for Native American Fine Art

Introduction

JAMES H. NOTTAGE
*Vice President and Chief
Curatorial Officer
Eiteljorg Museum of
American Indians and
Western Art*

Art Quantum: The Eiteljorg Fellowship for Native American Fine Art, 2009, is the sixth iteration of this biennial event. In the five preceding rounds of this remarkable program, the museum has produced matching catalogues, exhibitions, and symposiums. Up to this point, thirty well-deserving artists have received attention and recognition and twenty-nine authors have helped us better understand the artists' work and their accomplishments and contributions to the world of fine art.

To begin the second decade of Fellowship, we have identified five new artists and brought together talented and thoughtful writers to explore their work in the pages of this catalogue. John Vanausdall, president and CEO of the Eiteljorg Museum, sets the stage with his foreword, telling about the growth and development of the program. Jennifer Complo McNutt, curator of contemporary art at the Eiteljorg, directs the Fellowship program and is joined by Ashley Holland (Cherokee), our assistant curator of contemporary art, in providing an opening essay. They introduce the reader to the idea of an "Art Tribe" that has grown from the Fellowship program and discuss how factors other than biological heritage connect artists through their work.

Paul Chaat Smith (Comanche) is associate curator at the National Museum of the American Indian of the Smithsonian Institution (NMAI). He has contributed numerous essays to books and catalogues in the field. His most recent book is *Everything You Know About Indians Is Wrong* (University of Minnesota Press, 2009); and in 2008, he co-curated and co-authored *Fritz Scholder: Indian/Not Indian* for NMAI. His essay, "No Fixed Destination," brings humor and thoughtful prose to our dialogue about art and about Native America.

Alfred Young Man, Ph.D. (Cree), is professor and head of the department of Indian Fine Arts at First Nations University of Canada, Regina, Saskatchewan. His most recent book is *You Are in Indian Country: A Native Perspective on Native Arts/Politics* (Banff Press, 2007). Young Man, who has contributed to numerous other publications in Canada and the United States, writes for us about Invited Artist Edward Poitras (Gordon First Nation).

Gail Tremblay (Onondaga/Micmac), who teaches at Evergreen State College in Olympia, Washington, writes for us about artist Jim Denomie (Ojibwe). Tremblay's teaching focuses on writing, contemporary Native American literature, weaving, art history, Native American studies, poetry, and multicultural literature. She has contributed many essays to the literature.

Jimmie Durham (Cherokee) is well-known as an artist, poet, author, and activist. His fiercely independent voice helps us to appreciate the work of fellow Jeffrey Gibson (Mississippi Band of Choctaw/Cherokee). Durham's work was featured in the 2003 survey exhibition at Le musé d'art contemporain de Marseille, *From the West Pacific to the East Atlantic*. Durham co-wrote the catalogue and co-curated the exhibition, *The American West*, for the Compton Verney gallery in Warwickshire, England (2005).

Lee-Ann Martin (Mohawk) is curator of Contemporary Canadian Aboriginal Art at the Canadian Museum of Civilization, Gatineau, Quebec, and adjunct

professor in the Department of Visual Arts, University of Ottawa, Ontario. Martin has contributed to previous rounds of Fellowship and in this volume provides an insightful essay on Faye HeavyShield (Kainai-Blood). She has written extensively and curated many exhibitions in the field of Native American and First Nations art.

Finally, Polly Nordstrand (Hopi/Norwegian) brings our attention to the work of Wendy Red Star (Crow). Polly is a doctoral student at Cornell University in the history of art and visual studies. From 2004 to the present, she served as associate curator of Native art at the Denver Art Museum, where she curated exhibits on contemporary American Indian artists including Fritz Scholder and Harry Fonseca.

The 2009 Eiteljorg Fellowship for Native American Fine Art began in 2007 with a process to select the next round of honorees. We would like to express special thanks to the selectors who brought their expertise to that task, identifying the Fellows profiled in this catalogue. The selectors were Paul Chaat Smith (Comanche); Dana Claxton (Lakota), First Nations artist who was designated an Eiteljorg Fellow in 2007; and Anne Ellegood, curator at the Hirshhorn Museum and Sculpture Garden in Washington, D.C. ■

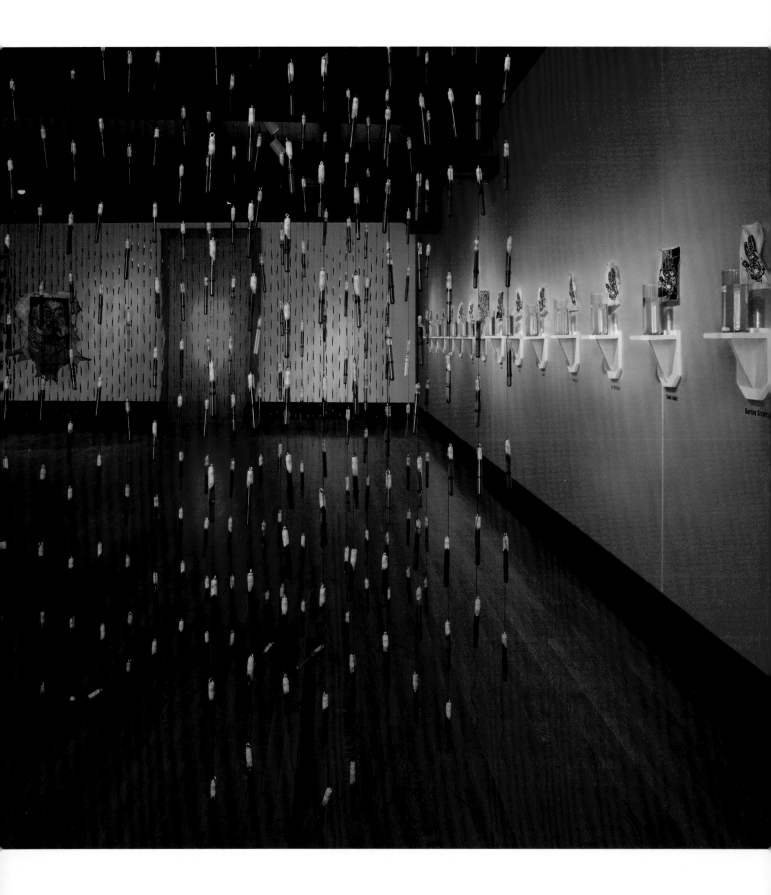

Art Quantum THE EITELJORG FELLOWSHIP FOR NATIVE AMERICAN FINE ART, 2009

JENNIFER COMPLO
MCNUTT *and*
ASHLEY HOLLAND
(*Cherokee*)

Naming the biennial Eiteljorg Fellowship for Native American Fine Art exhibition is an imposing challenge. The breadth of the work, the diversity of the artists (despite the common perception that "Indian is Indian"), and our commitment to the integrity of the program, combine to create a unique problem. In some years, we have deliberated arduously, and in others, we have simply stumbled onto the right title. This year, *Art Quantum* is no accident.

In 2007, the Eiteljorg Fellowship had the honor of hosting a Homecoming through funds provided by the Ford Foundation. These funds allowed the Fellowship artists, almost thirty in number, to come back to the museum for the 2007 Fellowship opening weekend, and to participate in reflection, discussion, and constructive commentary. During the intimate and lively gathering, and at other times during the opening weekend activities, the artists often referred to themselves as an "Art Tribe." A word like "tribe" can be understood in many ways, but in this context, the artists, though from different geographic locations and cultural affiliations, all saw themselves as connected by art. Rather than allowing federal standards to determine their ability to participate in the Fellowship, the artists viewed their eligibility through the universal process of art creation and collaboration.

The quantum facet of *Art Quantum* has strong, often negative, connotations for Native people. The word "quantum" in this sense comes from the process of utilizing blood quantum laws to determine an individual's inclusion in a Native group. It is this enrollment standard, stipulated by the Indian Arts and Crafts Board Act of 1990, that the United States and tribal governments impose on artists who want to sell their work as "Native American" art. Like many laws, there are benefits and drawbacks. While a blood quantum law or a similar enrollment requirement prevents imposters from producing art and mislabeling it, therefore appropriating a false identity, it also restricts those Native artists that, for various reasons, do not adhere to a quantum requirement or are unable to meet enrollment specifications. Consequently, they do not receive tribal benefits, such as health care, otherwise guaranteed through federal and state programs. Veronica Passalacqua, who wrote an essay about Fellow Tanis S'eiltin's work in *Into the Fray*, the 2005 Eiteljorg Fellowship catalogue, addressed these issues.

Becoming a landless people is one of S'eiltin's concerns, which she has complexly intertwined in the large installation *Resisting Acts of Distillation*, 2002. Occupying 1,000 square feet, the installation challenges issues of individual land allocation, Alaskan corporate establishment and land stewardship, federal status recognition, and most dramatically, blood quantum requirements that have been integrated into all of these issues.[1]

What is the formula for authentic Indigenous art and artists? How do we quantify who is a Native artist and who is "just" an artist? Blood quantum laws can often function as a way to keep individuals out. Art Quantum does the opposite and is a common ground and language. Art Quantum is the gathering strength of a visionary group of artists that is growing and bringing others into the "Art Tribe." Blood quantum

Tanis S'eiltin, *Resisting Acts of Distillation*, 2002. Mixed media.

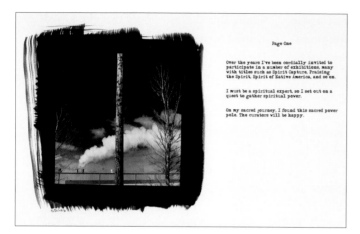

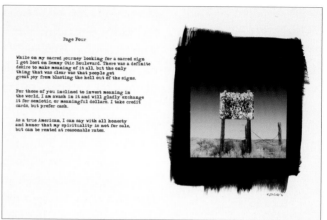

Left: Larry Tee Harbor Jackson McNeil, *Sacred Power Pole* (from *Sacred Arts* series), 1998. Digital print.

Right: Larry Tee Harbor Jackson McNeil, *Sacred Journey* (from *Sacred Arts* series), 1998. Digital print.

sometimes erroneously determines who is not authentic. Art Quantum looks to its peers to identify and honor what is truly authentic, and in each case, the manner in which an artist expresses his/her Art Quantum of identity is different. In an exploration of identity, James Luna (Luiseño) created a faux rock and roll installation, *All Indian All the Time*. Fritz Scholder (Luiseño), by his own declaration that became the title for his posthumous retrospective at the National Museum of the American Indian in Washington D.C., was *Indian/Not Indian*. George Morrison (Chippewa) viewed himself as an artist who also happened to be an Indian. The Fellowship Homecoming artists placed their identity within the "Art Tribe."

Native artists have very individual ways of defining identity amid laws, stereotypes, and the expectations of audiences. Larry McNeil (Tlingit/Nisgaá), a 2007 Fellow, found poignant and humorous ways to poke fun at the expectations curators and audiences have when looking for "Authentic Indian Art." In his work *Sacred Power Pole*, text adjacent to an image of an electric power pole stated,

Over the years I've been cordially invited to a number of exhibitions, many with titles such as Spirit Capture, Praising the Spirit, Spirit of Native America, and so on.

I must be a spiritual expert, so I set out on a quest to gather spiritual power.

On my sacred journey, I found this sacred power pole. The curators will be happy.[2]

In another work, *Sacred Journey*, McNeil teases with the image of a bullet-riddled sign and text that declares:

While on my sacred journey looking for a sacred sign I got lost on Semmy Otic Boulevard. There was a definite desire to make meaning of it all, but the only thing that was clear was that people get great joy from blasting the hell out of the signs.

For those of you inclined to invest meaning in the world, I am awash in it and will gladly exchange it for semiotic or meaningful dollars. I take credit cards, but prefer cash.

As a true American, I can say with all honesty and honor that my spirituality is not for sale, but can be rented at reasonable rates.[3]

The Eiteljorg Museum of American Indians and Western Art adheres to the Indian Arts and Crafts Board Act when determining artist eligibility for the Fellowship of Native American Fine Art.[4]

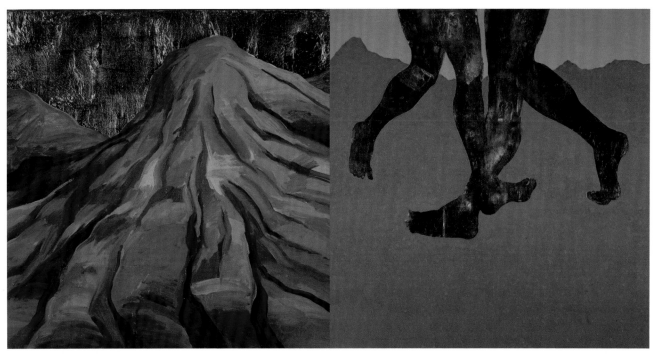

Kay WalkingStick, *Gioioso Variation II*, 2001. Oil and gold leaf on wood. Collection of the Eiteljorg Museum.

The museum also includes Canadian or First Nations artists like 2009 Invited Artist Edward Poitras and Fellow Faye HeavyShield. The Fellowship, however, does more than simply follow legal obligations, and does not adhere to political borders. Such requirements do not singularly determine the exhibition and artist selection. Instead, it is the goal of the Fellowship and the Eiteljorg Museum's mission to be a starting point and platform for exploration of Native identity and artistic expression beyond concepts of blood quantum laws. It is through the concept of an "Art Tribe" that all Fellows are welcomed into the elite group of Fellowship artists, now numbering thirty-five. While mandatory laws and legal stipulations may determine primary eligibility, it is a peer evaluation that strengthens the "Art Tribe" through the addition of new members each biennium. Art Quantum is the requirement for membership in this "Art

Tribe," and every Fellowship artist exemplifies this through his/her work.[5]

Art Quantum is found in the political commentary and playful and/or acerbic teasing of Indigenous artists, but its core is in their depth of experience, technical expertise, and aesthetic sophistication. In other words, 10,000 years of history and the determination to survive and thrive produce some poignantly rich artwork. While Art Quantum does not have the obvious physical boundaries of blood quantum, it is clearly present in our former Distinguished Artists and Fellows.

For example, 2003 distinguished artist Kay WalkingStick (Cherokee) paints works that look like silk has fallen onto the canvas. In *Gioioso Variation II*, the golden glistening legs of two dancers tangle through a romantic evening in Italy, flanked by a monumental mountainous landscape bold, brilliant, and luminous. WalkingStick's signature diptych format represents personal experiences as a

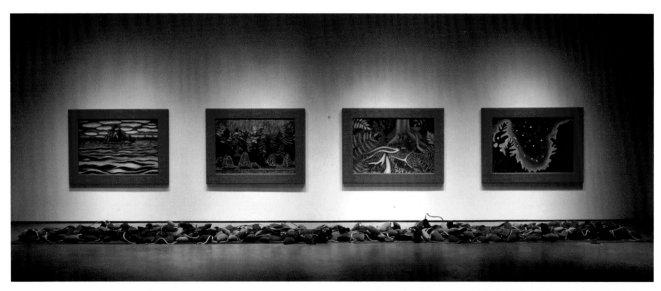

Shelley Niro, *Unbury My Heart*, 2000. Mixed media. Collection of the Eiteljorg Museum.

Native woman, a teacher, traveler, and mother.

A 2001 Fellow, Shelley Niro (Bay of Quinte Mohawk), represents the 500 tribes in *Unbury My Heart*. It is a textural and tactile expression of her many experiences as a Native person. She illustrates the connection between Indigenous people by attaching 500 velvet hearts to a continuous velvet rope. Her frustrations over fishing rights that non-Natives dispute inspired this seascape, and she finds her love and need for solitude and rejuvenation in the woodland landscape. Niro uses rich color and lush material to express often harsh realities like genocide, loss, and ultimately the enduring Indigenous presence. Niro is a versatile artist equally facile behind the camera, making photographs or film.

Nineteen ninety-nine Fellow Truman Lowe's (Ho-Chunk) cascading waterfalls and floating canoe forms are easily traced to his woodlands culture. Readily available materials transformed into rushing water and "a canoe that is neither on the water nor in the air," but somewhere in between, are elegant expressions of com-

plicated concepts made so simple that they allow the viewer the "room" to go deeply into the many layers of meaning or interpretation. Whether Lowe is telling a story or reinventing water in wood, the technical simplicity and clean aesthetic adds great depth to the work.

Two thousand five Fellow Marie Watt (Seneca) has stated, "You are received in a blanket and you go back in a blanket." Blankets are used to care for the sick, and shape themselves in patterns through individual use, the way a shoe is broken in differently for each wearer. Blankets represent stories and family histories. And blankets are quiet. Even when it is thrown on the floor, nothing but comfort and quiet comes from a blanket. Whether they are stacked into totems, cast into bronze, or hanging on the wall like *Braid*, the only language one needs to enjoy and understand this work is the human language. The work is brilliantly universal.

In 2009, we usher five new artists into the Eiteljorg Fellowship and "Art Tribe." Like their predecessors, they bring individual interpretation of their

own experiences as Indigenous artists, "artists who happen to be Indian," *Indian/Not Indian* and *All Indian All the Time.* Artists in the "Art Tribe" are sometimes connected by blood quantum, and always by the bittersweet experience of being an Indigenous person whose history is vast and whose determination is expressed in work that carries the authenticity of centuries of surviving, thriving, and being. Their Art Quantum is impossible to measure. ■

1 Veronica Passsalacqua, "Tanis Maria S'eiltin: Coming Full Circle," in *Into the Fray: The Eiteljorg Fellowship for Native American Fine Art, 2005* (Indianapolis and Seattle: Eiteljorg Museum of American Indians and Western Art in association with University of Washington Press, 2005), 101.

2 Mique'l Icesis Askren, "Larry Tee Harbor Jackson McNeil: Visual Myth Maker," in *Diversity and Dialogue: The Eiteljorg Fellowship for Native American Fine Art, 2007* (Indianapolis and Seattle: Eiteljorg Museum of American Indians and Western Art in association with University of Washington Press, 2007), 86.

3 Ibid., 93.

4 The 2009 Eiteljorg Fellowship for Native American Fine Art's submission requirements in the Call for Artists application states, "Due to the stipulations of the Indian Arts and Crafts Board Act, artists must include proof of enrollment to be eligible."

5 For more information on blood quantum, the Indian Arts and Crafts Board Act of 1990, and other issues concerning tribal affiliation and enrollment requirements, please visit the Bureau of Indian Affairs Web site at http://www.doi.gov/bia.

Marie Watt, *Braid*, 2004.
Reclaimed wool, satin binding.
Collection of the Eiteljorg
Museum.

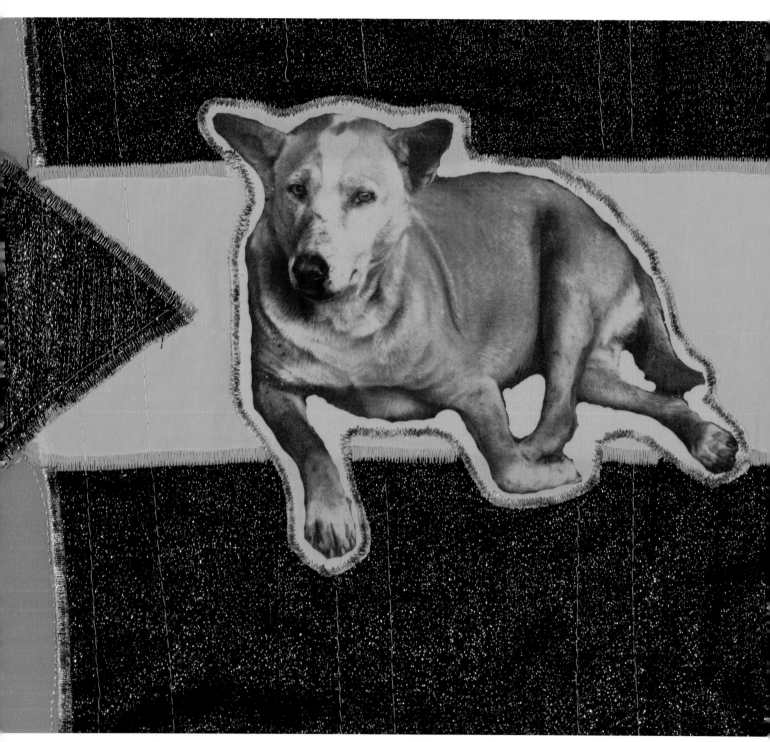

Wendy Red Star, *Rez Dogs* (detail), 2009. Fabric, ribbon.

No Fixed Destination

PAUL CHAAT SMITH
(*Comanche*)

I cannot wait for it to be over. As I am writing, just five months and change before we can send this horrible, unnamed misadventure to the dustbin of history. Ten years of colossal failure on every front. A decade so lame, a collective failure of imagination so vast that we could never even agree on what to call it. By 2002, everyone quit trying to name the thing, and it feels like we've been marking time ever since, like jailed prisoners with no chance of parole.

The first U.S. national election, back in 2000, remember that? It came down to one state, conveniently run by the brother of the winning candidate, finally decided weeks later by a bitterly divided Supreme Court. That Tuesday morning in September. Afghanistan. Iraq. Another absurd presidential election. Katrina. Iraq. Afghanistan. A booming economy, kind of, until it crashed, and we all found out big chunks of the booming economy were essentially fraudulent. The New York Stock Exchange is back where it was at the end of the last millennium, as if the last ten years never happened.

I am still sentimental about my country, so let's agree that the beginning of the end of the Unnamed Decade was November 4, 2008, when the same country that elected Richard Nixon twice and Bushes three times chose, by a decisive majority, a black guy named Barack Hussein Obama to be their new president. Seriously, who saw that coming? And who knows how the Barry Hussein Project is going to work out? Anyway, that's a problem the lead essayist for the 2019 Eiteljorg Fellowship for Native American Fine Art catalog can address. Right now, we're making an assessment about the state of Native American fine art, an assessment that looks at empty cargo jets, the three classes of Indians, and the 1992 film *Basic Instinct*.

We'll start with the jets.

Sometime during the end of the last century, people started to be defined by their relationship to aircraft. Actually, to planes and airports. If you lived within an hour or two of a huge city, with a huge airport, you were part of the world. If you lived hours and hours and hours away from Chicago or Miami or New York or Los Angeles, you were not. Rather, you probably occupied a dirt patch in Flyover Country, and spent your days growing watermelons and lima beans, and looking forlornly up into the heavens, as the good people leave contrails that might as well have spelled out, "So Long, Losers!" in their wake.

The planes didn't always carry passengers. Sometimes they carried packages, and sometimes they even flew around empty, waiting for packages to accumulate. Really, they did.

I discovered this in October 2005, three months after a hurricane and government incompetence nearly destroyed New Orleans. My wife and I were flying from Washington to Vancouver on a discount airline called Independence Air that no longer exists. Halfway across America, Lynora handed me the business section of the *New York Times*, and pointed to an article. "You'll want to read this," she said.

Memphis—The nearly empty Airbus 310 was coasting through the Alabama night sky when a message Xashed in the cockpit. "divert," it said, before using code to order the plane to land in Atlanta. The pilot banked the jet to the east and a half-hour later it was on the

ground. There, its cargo door opened up to a group of waiting FedEx employees who began Wlling it with 17,000 pounds of cargo.

It had been a busy day for Georgia businesses, and FedEx's regular nightly Xights from Atlanta to the company's Memphis hub were overbooked with packages. So the local crew made a call to a sprawling, low-slung room here at headquarters, where people hunch over computer screens showing weather maps and Xight plans, and asked for help from the Wve empty FedEx jets that roam over the United States every night.

The recent birth of that small Xeet, at a multimillion-dollar price tag, explains a lot about how the nation's economy has become so much more resilient. Think of it as the FedEx economy, a system that constantly recalibrates itself to cope with surprises.[1]

Wow. Five empty FedEx jets roaming over the United States every night, waiting for a message that often never comes, ready to land at any of a dozen cities at a moment's notice. I won't tell you how many hours I've spent thinking about those empty planes flying through the American night, just that it was really a lot. A business article about recessions became for me a poetic story, rich in metaphor and meaning.

But I didn't really know why those planes fascinated me so much, or what I thought they meant. I just found the whole concept so beautiful: those huge, empty airplanes flying with no fixed destination, waiting for the flashing light that most nights never flashed, apparently extravagantly excessive, but actually saving time and money and even preventing recessions. I thought about the loneliness of those earnest airplanes, desperately hoping to be useful yet, so often

landing in Memphis after a long night of nothing. I imagined the airplanes as somehow alive, feeling a very American sort of loneliness, where it's always a quarter to three in the morning and Frank Sinatra's on the cockpit radio. Like Edward Hopper's *Nighthawks*, except with giant airliners at the diner instead of people.

I'll bet those empty jets aren't flying around empty anymore. In 2005, America was big, imaginative, and rich. Four years later, the FedEx economy, blown away by surprises nobody saw coming, has been replaced by the Great Recession.

Flyover Country includes the Pine Ridge Indian reservation in South Dakota, home of the Oglala Sioux. And let's admit something right off the top, before we discuss our main topic, which is really important, namely why there are three classes of Indians, how to identify them, and what it means to each of us. Believe me, there's lots to say, and by the time we're done, you are going to be wondering how you made it all these years without this knowledge. I mean, that's what I thought—"How did I stumble through life absent this knowledge?" How much of this stumbling might have been prevented, if someone had just told me about the three classes? Here's my guess: a lot. I'm not saying I'd have spent the last few decades as the second coming of Fred Astaire or anything, but I am dead sure the world would have seen a hell of a lot less of PCS tripping over his own feet.

Back to the admission: I think it's time we formally acknowledge how much we owe the Oglala Sioux. They are the most famous, most studied, most

photographed, most feared, most heroic Indians of them all. Best. Indians. Ever. They are like the Academy Awards that year when Titanic swept every category. The rest of us have no chance, we're just glad to have been nominated. (But not really, we're just saying that.)

I would also like to take this opportunity to apologize for once writing that compared to my type of Indian, the Comanches, the "Sioux were a bunch of Girl Scouts." To all Sioux people and also all girls who are now or ever were Girl Scouts: Sorry! Just kidding!

And because they are the most studied, scary, heroic, and interesting Indians ever, the Oglala Sioux have much to teach the rest of us. We can learn from the sidelines, so to speak. Personally, I love being on the sidelines, watching, observing, listening, and avoiding arrest.

Thank you, Oglala Siouxs!

So here it is, the three classes of Indians, from the notebooks of famed anthropologist Dr. Scudder Mekeel, who was writing from Pine Ridge in 1930: "Appear to be three main classes of Indians: 1. Christian and trying to be acculturated. 2. Pagan and living as near as possible in old way, and perhaps succeeding spiritually to some extent. 3. The in-betweens—loafers, criminals, delinquents. The first two are fine individuals—the third (by far the majority) are all bums."[2]

Well, he's got us there, hasn't he?

I sense Dr. Mekeel is rooting for class two Indians, even though he knows they are doomed, since living as near as possible in the old ways isn't very near at all, and has no future. But dammit, they're trying something at least, and he believes they are "perhaps succeeding spiritually

to some extent." I don't know what he means by that, but it's a lot more than he says about class one, with his back-handed slap that they are "trying" (i.e., failing) to be acculturated. To me, this says Dr. Meekel likes the pagans more than the Christians. And really, who doesn't?

No ambiguity about what he thinks of class three, and that's probably what everybody thinks about class three, especially all of us who are in class three. We know we're loafers, criminals, delinquents, and bums. I wouldn't say we're proud of it exactly. It is what it is. Because, admit it, nobody really liked the Christian acculturation project that much. It was boring and impossible, because all the Bible reading in the world couldn't change the fact we were Indians trying to be Christians, and even when we really believed we were Christians, everyone is like, "Why are those Indians trying to be Christians?"

Loafing drove white people nuts, especially in the nineteenth century. Standing around the trading post, the fort, outside the train station, sitting by the highway, or the liquor store. Criminality at least shows some initiative; the Indian criminals and their delinquent fellow travelers at least get up in the morning with the goal of acting in an anti-social way, which takes planning and coordination. Loafing takes nothing at all. Joining the fraternity of bums, paradoxically, takes zero effort.

If most Indians were bums in 1930, does it follow that we are bums today? Yes. The vast majority of us are still bums, even though we've produced a disconcerting number of goal-oriented coffee achievers who run large businesses

and fly on the space shuttle and so forth. Actually, we are proud of them, and salute them as we head to our afternoon nap. Napping is important, because even though loafing is easy, it takes more than loafing to achieve in-between-ness. The question is, why do most Indians choose to be class threes? I think because we understand that loafing is the most effective way to annoy the largest number of people.

Look at it this way: imagine the problem as the Missouri river. On one riverbank is class one, the trying to be Christian side, once known as the future. On the other riverbank is class two, the pagans and the whole spiritual thing, which we can call the past. Right there in the middle of the Missouri river, on a big, long, sandy island, are the huddled masses of Indians who are in between (get it?) the past and the future. What are they doing? Not much. Loafing. Throwing pebbles in the river. Sleeping. Making snarky comments about the ones and the twos. Watching clouds.

This may not seem like much, but it's way smarter than it looks, and here's why: class three is neither past nor future, Christian or pagan. It's just a kind of indigenous Lumpenproletariat that says little to the world, except, "What are you looking at?" The threes project a kind of postmodern alienation that would be at home in a John Updike short story or a Jim Jarmusch movie. Also, quantum physics argues that uncertainty, in-between-ness, if you will, is embedded in the fabric of the universe itself, and if I actually understood what that meant, I would say more about it.

Advanced physics. Frequent napping. Reluctance to get with the program, or

any program, for that matter. Yes, we're talking about the artists of the Red Nation.

What have they been up to lately? Lots, actually. They've been going to art school in droves, including the famous ones in Chicago and Rhode Island and New York and London. They go to the Venice Biennial, to Documenta, Miami Basel, and the Armory Show.

We go here, and we go there, yet I see us always returning to the island. Make no mistake, the island has been good to us, it made us who we are, but lately I've been thinking it may be time to leave the Missouri River for the Indian Ocean.

Why now? Because ideas and circumstances and planets are aligning in ways that offer new opportunities and new responsibilities. Last year, the Prime Minister of Canada apologized before Parliament and a national television audience for the destruction its boarding school policies visited upon aboriginal people. The American president is black and white, African and American, of Kansas and Kenya. A cultural shift is taking place that increasingly understands race is fiction, racism is not, and that essentialist ideas about racial purity are losing ground. Our children are being taught that it is a scientific certainty that all humans originated in Africa.

The world increasingly understands itself as the result of fantastically complex histories and connections that make us all, as the Oglala Sioux teach us, related. But not in a gentle, New Age way, but in a noisy, confusing, Bladerunneresque, race-mixing, high definition thriller, which has always been closer to our real past than the fairy tales we believed but understood were never really true.

The job description for serious artists is to fearlessly engage the biggest questions of their time. And it so happens the biggest questions of our time are ones that we know well. Curator Okwu Enwezor in 2002, in the aftermath of 9/11, spoke of the "terrible nearness of distant places," which exactly describes what took place five centuries ago, when halves of the world previously unconnected became one. Our vantage point is unique and valuable, can be of great importance, if we accept the challenge of addressing the biggest, toughest questions, the ones without easy answers. It means choosing hard targets.

As Faye HeavyShield, Jim Denomie, Edward Poitras, Jeffrey Gibson, and Wendy Red Star demonstrate, Native artists can productively and imaginatively explore Christianity, museums, and stereotypes. They stand in contrast to many Native artists who settle for easy targets and tiresome rhetoric.

Jimmie Durham once described our contract with the art world as much like the notorious interrogation scene in *Basic Instinct*, as Sharon Stone crosses and uncrosses her legs, revealing to her police interrogators and the viewer that she is wearing nothing underneath her dress. Durham compares this with our strategy of telling the world that it can see this much of ancient and supercool spirituality, but only this much, and no more.

A brilliant set piece of strategic essentialism, and we've certainly got a lot of mileage from it, but clearly the scene has gone on way too long. It's doing nothing for us, and is boring the audience to death. *Basic Instinct* came out in 1991, coincidentally a year before the Columbus Quincentenary, a high point of the American Indian strategic essentialism project.

No more teases. There is a bigger game, a more universal truth, and I want all of us to step up and meet our responsibilities. When our work fails to have the impact we think it should, our solution is to vote someone off the island, or make a new constitution for the island, or revise the dress code or the vision statement. Instead, maybe it's time to leave the island altogether.

Leaving home doesn't mean saying goodbye forever. We could have reunions every few years, catch up and remember the good old strategic essentialist days. And you know what, even if, out there in the big world, things don't work out, we could always come back to the sandy beach in the middle of Sioux country. People there are very forgiving.

There's work to be done, and a planet to save. I think we should give it a shot. ■

1 "The FedEx Economy: Have Recessions Absolutely, Positively Become Less Painful?" by David Leonhardt, October 8, 2005, *New York Times*, C13.

2 "The Anthropological Construction of Indians: Haviland Scudder Mekeel and the Search for the Primitive in Lakota Country," by Thomas Biolsi in *Indians and Anthropologists: Vine Deloria, Jr., and the Critique of Anthropology*, eds. Thomas Biolsi and Larry Zimmerman (Tucson: University of Arizona Press, 1997), 134.

Edward Poitras (GORDON FIRST NATION) **SHOWING US THE WAY**

Born in Regina a member of the Gordon First Nation, Poitras is a Métis with an Indian treaty card, or a treaty Indian of Métis and Indian ancestry. His father, a Métis, and his mother, a Plains Cree/Saulteaux, met at the Indian residential school in Lebret, Saskatchewan. As a young man, Poitras quickly learned that neither people on the reserve nor in the city accepted the contradictions of his mixed cultural heritage.[1]

—LEE-ANN MARTIN

ALFRED YOUNG MAN
(*Cree*)

Edward Poitras grew up in Regina, Saskatchewan, and is a status member of the Gordon First Nations Reserve, located sixty-five miles northeast of Regina. Like many Indian artists, or artists who happen to be of "Native ancestry," Edward works under the awkward auspices of identity politics. According to the Department of Indian and Northern Affairs in Ottawa (the DIA, counterpart to the Bureau of Indian Affairs in the United States [BIA]), Edward is considered an Indian under the Indian Act, the primary instrument of parliamentary law that regulates an Indian's life from birth until death—and sometimes after. The history of that white man's law and its effects on Indian life for more than a century is replete with suffering, loss of parents and family, death, residential school abuse, theft of land, resources, and culture. Edward's life, like all status Indians, is still regulated like no white man or woman's life ever could be.

The past 150 years of Métis history in Saskatchewan and Manitoba are marked by tremendous cultural and economic change and turmoil, all sustained by great political change and uncertainty. The late-nineteenth-century political hero Louis Riel figures prominently in that history. If you were to ask any Métis on the prairies or the streets of Regina, Saskatoon, or Winnipeg who the single most identifiable Métis figure in Canada might be, Louis Riel would be the first mentioned, hands down. Edward Poitras, by self-identification, is of that culture, is of a group of people who are forging their own sense of identity, history, and cultural integrity. Edward, and his art in particular, come out of a place where a duality of identity reigns— hence, identity politics—but it has not always been that way for the Métis.

When I was growing up in Montana, my grandfathers and great-grandfathers, who were of Cree and Métis ancestry, often spoke of their own Métis ancestry in Canada. Those great-grandfathers knew Louis Riel personally, even assisted him when he fled to Montana, escaping to what is now the Rocky Boy Indian reservation, fleeing from the political tyranny and insanity that was Canada.

Unlike the contemporary situation, those great-grandfathers and grandfathers spoke of the Métis as being Indians rather than French-Canadian or English or white, meaning there was no separate Métis identity as such, at least not exactly in the same way we now know and understand the Métis' claim to their separate identities and place. I was taught that the Cree and Métis were as one people, and because many Métis spoke Cree in those early times, the line that divided the two peoples was difficult to determine.

It was only after I came to Canada in 1977 that I learned that the Métis see themselves as separate and distinct from those people whom the Indian Act

1. Edward Poitras. *Home and Garden* (detail), 2009. Wood, paint, rice, dollar bills, cloth, nylon rope.

defines as Indians. There seemed to be a closer tie and association between the Métis and the Cree people in my great-grandfathers' and grandfathers' time. I have spoken of this fact with Edward, relating how he would have been measured as an Indian person by my grandfathers and great-grandfathers, whose parents were from different parts of Alberta and Saskatchewan. This would be true no matter what the Indian Act dictated. By contrast, Indian people now defer to Parliament to dictate which person is an Indian within the meaning of the Indian Act, and by default, so do the Métis.

It is completely reasonable and appropriate to assume that Edward's art and personal philosophy is influenced by his Indian ancestry and that Métis culture and history is in fact Indian. His art is certainly linked with the First Nations people in Saskatchewan and, through his mother, connected to the Saulteaux. Of course, there are many different kinds of Métis throughout Canada and in the north-central United States, but without going too far and into too much detail, suffice it to say that the Métis to whom I am referring are those people from the regions in and around Prince Albert, Batoche, Duck Lake, La Ronge, and the Touchwood Hills people of Saskatchewan. These are the Métis with whom I am most familiar and from whom Edward's ancestry originates.

In this way, I consider Edward to be an Indian artist, in every sense of the word. Then too, I accept that there will be those Métis who will disagree with me, since it is a dead anthropological certainty that historically, a people forg-

ing their own sense of identity and history will often react defensively about how others may view them or may be describing them. Canadians and Americans do this themselves, constantly, but as I said, it has not always been that way.

Edward had this to say about the identity question:

Hi Alfred

Okay man here it is. Clearing up the things that have come back to haunt me and need to be put back into context.

The first bit of info was from an interview with Gerald McMaster back in the late eighties, early nineties. Just talking about identity and place. When I spoke about this period it was when I was very young on the reserve staying with my grandparents. One event where I saw it coming from both sides and would only understand many years later with a news paper article that my grandfather had given me. It was from the early fifties after the Royal Commission of 1950, which was to determine who was eligible to stay on the reserve.

Conditions being what they were at that time and there being few jobs as it is now. There tends to be discontent and when the opportunity to questions ones origin became available. My grandfather's brother went after Jacob Bird who was chief at the time and its true his origins were questionable. He was adopted by this old lady on the reserve who refused to disclose his origins. So why would they even question his origins, well he had blue eyes and was a bit different, but that wasn't enough. Maybe my grandfather's brother thought that since my great grandfather was chief and my grand father was chief that maybe he was also entitled to be chief and thought he had a more substantial his-

tory. The other being questionable and with the opportunity to get rid of him, it went to court which created a certain amount of division. It was north and south and my grand uncles family eventually left the reserve after he died and transferred to their mother's band. So the consequences were felt for some time after this Royal commission.

I personally felt the old lady had every right to be the mother of that child and this speaks of human nature to care for each other. A child will die without human contact. The fact that the government had taken away the children and interfered with the adoption practices of first nations is somewhat inhuman. The adoption of children is as natural as having them.

When this subject had come up again this past spring. I thought why is it that non-Indian people want to hear that first nations are also discriminatory when in fact I believe it is something new and is primarily based in a lack of identity with a generation raised on the outside. Sort of like outlaws, the unconnected that lash out and live with a surface appearance of being.

In the discussion leading up to the signing of the treaty covering this area. One chief said "out here you see before you many kinds of grass and my love is such that I love them all." There were a number of references to the Métis and the Half-breeds during this discussion and it was a main point that needed to be addressed. This I feel is still an issue and I want to make a presentation to the chiefs of treaty four to talk about the events leading up to this point and other documents that are relative to this event.

The Early Years

Edward has been around the contemporary Native art scene in Canada since the early period and he knows its history well—he has interacted with Native artists on and off reservations and reserves for many years in both the United States and Canada. In 1974, he studied with Sarain Stump (1945-1975), who played a seminal role in creating the Indian art program at the Saskatchewan Indian Cultural College in Saskatoon, and in 1975–76, Edward studied with Domingo Cisneros at Manitou College in La Macaza, Quebec. These were two artists of mixed-race ancestry who were to become known as leading Native artists in Canada in their own right. While Stump was Italian-Cree-Shoshone from Wyoming, Cisneros is of a people called the Tepehuane from northern Mexico; it is said that Cisneros was born in 1942 in a funeral parlor in Monterrey, Mexico (west of Brownsville, Texas). Nevertheless, it is nearly impossible to find any Indian artist in Canada or the United States who even knew what a funeral parlor was during those days. In fact, to Native artists on the open plains, the ancient custom of burying their dead on scaffolding was not that distant a memory, for this was something that their great-grandfathers did in their time, perhaps even their grandfathers. Nonetheless, both Stump and Cisneros found incongruous places for themselves among the Native artists of Canada, definitely playing an essential role in Canadian Native art history, although such a state of affairs may say more about how Native art plays out in Canada than it says about Stump or Cisneros as artists.

Poitras began making his national mark on the Native art scene when he

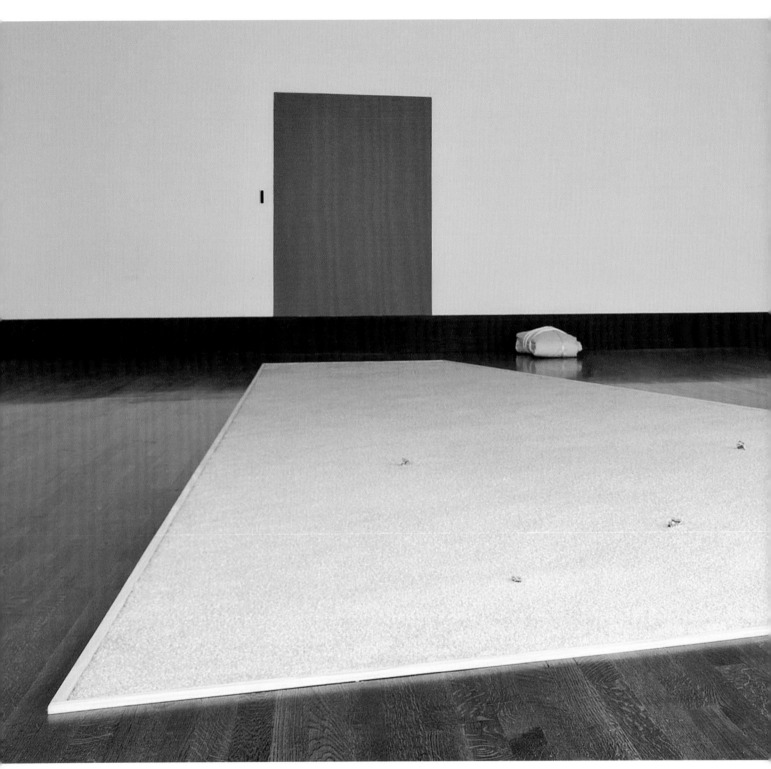

appeared in the exhibition *Horses Fly Too* (1984) at the MacKenzie Art Gallery in Regina, where he and another Métis artist, Bob Boyer (1948-2006), were paired up in one of the first art exhibitions of its kind, shown in what was then a predominantly white art gallery—culturally, that is—run by white directors and curators for white artists, the quintessential colonialist, neighborhood art establishment. The exhortations from artists in Native art circles across Canada in those days were unmistakable refrains of surprise. What were these two artists of Native ancestry doing exhibiting in this colonialist institution? How did they get there? Who did they have to bribe?

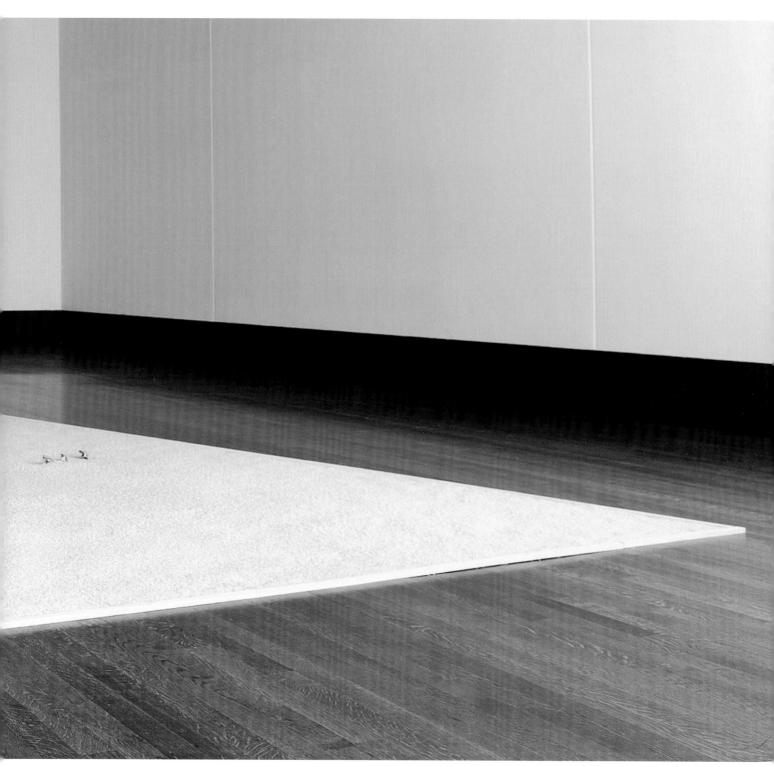

1. Edward Poitras. *Home and Garden*, 2009. Wood, paint, rice, dollar bills, cloth, nylon rope.

Clearly *Horses Fly Too* was breaking new ground in an otherwise racist country and chauvinistic art establishment, causing reverberations that are still heard in our present day.

In the late 1970s and throughout the 1980s, the Métis of the western provinces were coming to terms with their own identities, with their own culture and all that such things could signify, establishing and exercising their own good judgment with regard to their political pride and power, fighting the Canadian political establishment in Ottawa. They were moving forward at full strength, working to regain their space and intellect of place in Canada, free from the political and ideological

1. Edward Poitras. *Home and Garden* (detail), 2009. Wood, paint, rice, dollar bills, cloth, nylon rope.

oversights and confines of playing second fiddle (no pun intended) to Indians over at the DIA in Hull, Quebec. The Métis seem to have continued to make substantial change and progress in that area, and nobody with a logical brain in his/her head would ever make the unforgivable mistake of confusing them with Indians. How times change.

So, what has all this justification of having a dual identity, cultural, and political history to do with the Indian fine arts movement anyway, or with Edward? Edward came to us when the bodies politic of Canada and the United States were undergoing great transformation and reformation. In

Canada, George Manuel, a British Columbia Shuswap chief and politician and President of the National Indian Brotherhood from 1970 to 1976, was busy conceiving the idea of a worldwide alliance of Indigenous peoples to effect Indigenous rights wherever Indigenous people were. The word "aboriginal," which has now become part of the *lingua franca* of Canada, is a widely used and accepted way to describe and address Native people in Canada. The term, however, comes to us from out of the political turmoil of the 1970s, when Manuel and Blood Indian activist Marie Smallface Marule were organizing worldwide political events, including a book Manuel pub-

lished in 1974 called *The Fourth World: An Indian Reality.*

Marule was a tenure-track professor in the Native American Studies Department at the University of Lethbridge in Alberta, and she used the term "aboriginal" relentlessly in her classroom discussions and public presentations, so evidently there was a national and academic move to redefine Canadian Indians by something other than "Indians." Although ordinary Canadian and American Indian people on reserves and reservations have never readily accepted this peculiar depiction of themselves as "aboriginals" or as a way to identify themselves (principally because aboriginals as generally understood are in fact Indigenous Australian peoples known as Aboriginals), nevertheless, the classification seemed to catch hold. In Canada, whites and urban Indians alike began to use it, so much so that the tag seems to have adhered to typical nomenclature, though the expression is just another colonialist enforced representation, albeit being assisted by a few well-meaning but misinformed Indian individuals who seem not to have thought through the consequences of their actions. Significantly, on the reserves and reservations in both countries, use of that expression in everyday conversation simply does not take place.

Part of the difficulty and issue of identifying Edward as an "Indian artist" stems from that history and the politics therein. Adrian Clarkson was a CBC television news anchor before she was to later become Canada's Governor General, which is to say, she was the Queen of England's right-hand woman, Queen Elizabeth's representative in Canada. In matters of state, Governor General Clarkson spoke on behalf of the Queen on issues relating to Canadian and English affairs, including the Crown vs. Indian treaties, a relationship that should supercede the Canadian government vs. Indian treaties association but in fact almost never does.

Edward was chosen to represent Canada at the XLVI Venice Biennale in 1995 and Clarkson, as a television reporter, was one of his main supporters. Who could resist the polished political swagger of such a highly placed and respected personage as Clarkson, who elevated Edward to the lofty heights of countrywide prominence among Canada's artistic elite? Such art publications as *Canadian Art* and post-modernist art magazines like *Border Crossings*, the Canada Council itself, all trumpeted the Canadian choice of Edward as their representative. Canada had its first Indian artist leading the charge onto the world stage, although among the white art establishment, Edward was supposed to have been chosen simply on the basis of his being an artist with no cultural affiliation to speak of, that is, other than that of a Canadian artist. The publicity sent out nationally and internationally never dwelled on his Native affiliation. The questions that arose in the minds of Native artists were, "What does this have to say about Native art?" and "Where is Native art going?"

As it turns out, Edward's rise to fame and celebrity had very little, even nothing at all, to say about where Native art as understood by Native artists or

Native art historians was going. Native art was under-represented at the National Gallery of Canada, the Vancouver Art Gallery, the Royal Ontario Museum, and the Art Gallery of Ontario, so it was not even acknowledged. Those venues were not interested in Indian art per se, regardless of Edward's high profile, since their art policies claimed to exhibit only artists of no particular fixed address, political or religious persuasion, or cultural affiliation, or so it seems.

Although Edward was not a part of that Native art organization known as the Society of Canadian Artists of Native Ancestry (SCANA), which fought since the early days of the 1970s to promote and get Native art accepted as Art writ large at the National Gallery of Canada and other important institutions, nonetheless Edward was accepted by SCANA members as one of their own, even if Edward's teacher and mentor, Domingo Cisneros, was himself never a status Indian nor a member of SCANA.

Somehow, it seems, Edward rose to the stature and responsibilities of his professional distinctiveness without needing SCANA, but there was always an unspoken question among Native artists as to whether or not Edward could have reached the position without SCANA being in existence. How much influence did SCANA exert over the art aficionados in Ottawa, in Toronto, in Vancouver when it came to Native art? Indeed, would any Native artists in Canada have ever reached the positions of influence and notoriety they hold today without the landscaping done by SCANA for decades before? In any case, from all outward appear-

ances, Edward was able to negotiate his success on his own terms, in his own way, in his own style, on his own time. It could very well be that he did it all without SCANA's weight, but history will confirm or deny such an assertion.

Edward has a very firm grasp on his Native ancestry and he does not contest that connection, much like Boyer, who before he passed on was a powwow dancer, deeply involved in the spiritual ceremonial connection and integrity of the sacred pipe at the Saskatchewan Indian Federated College (FNUC).[2] Although Métis people are, some would say, politically estranged from the First Nations people in Saskatchewan, the artist Poitras is not of that political persuasion and neither was Boyer. In this way, there remains something of a schism between the authenticity that Poitras creates in his art and his concrete personal and political life and affiliations. That political dichotomy between his art and life is what informs his work most clearly.

Three artworks that Edward created in the 1980s come to mind. The first one, *Coyote* (1986), is a sculpture made out of hot glue and the bones of seven dead coyotes that Edward acquired from some farmers. He meticulously cleansed the meat with a chemical mixture, dried the bones, and reassembled them in the form of a celebrated coyote deity, a construction that could have only been born out of the mind of an Indian. If an artwork comes out of an Indian's mind, how then can that be called anything other than Indian art? Perhaps that is the true meaning of the term, Indian fine art. I have often wondered why the government of

Edward Poitras, *Coyote*, 1986.
Coyote bones, hot glue.

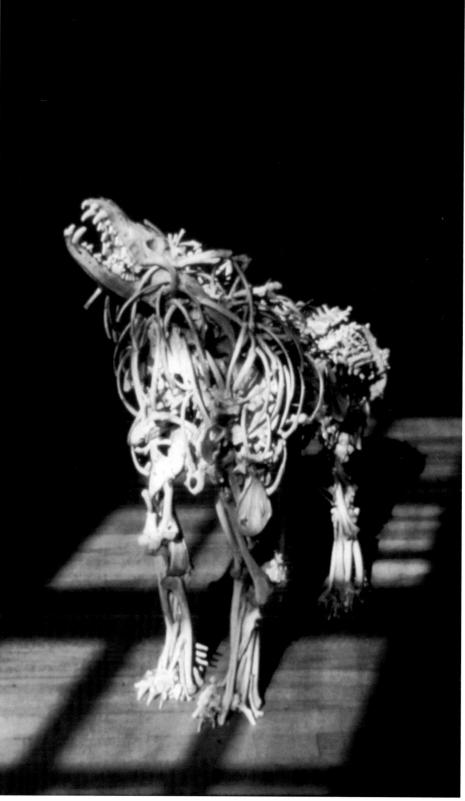

Edward Poitras, *Big Iron Sky*, 1984. Bone, wood, sand, wire, horsehair, various materials.

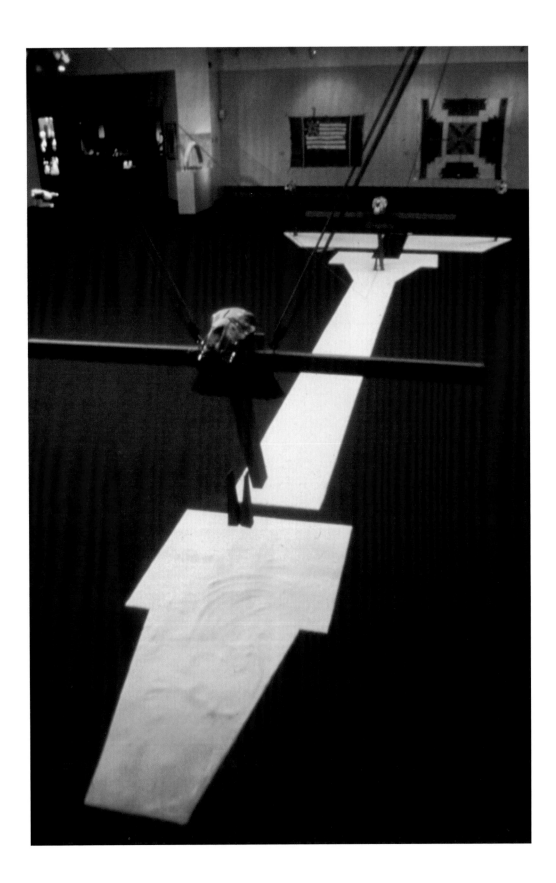

Edward Poitras, *As Snow Before the Summer Sun*, 1980. Bone, transistors, feathers, plastic, various materials.

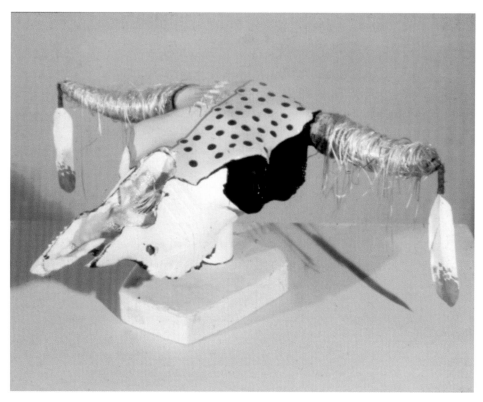

Saskatchewan's Art Board cannot be imaginative enough to provide the funding for Edward to re-create that sculpture on a massive scale, say around thirty feet high, to stand beside the trans-Canada highway outside Regina, welcoming the people of the world to Cree land.

The second artwork, *Big Iron Sky* (1984), made of bone, wood, sand, wire, horsehair, and various other materials, is on the cover of the exhibition catalogue for *Horses Fly Too*. The skull of a horse is agonizingly tethered by cables, skewered between posts of wrought iron, to subconsciously symbolize western civilizations' massacre of the mega fauna of America, the bison, grizzly bear, elk, wolf, mountain lion, brown and black bears. A medieval English practice of torture is recalled, of stretching a victim by the limbs, by the wrists and ankles, between two turnstiles—the rack—as the wheels are turned slowly, unremittingly, tearing the victim apart. The torment implied in that sculpture is subtle but unmistakable, and speaks to a deeper reality of the Indian's existence in Canada.

Canadians, to the contrary, often boast that historically, they treated "their" Indians better than the United States did "theirs," as if Indians could be owned by anyone. Then too, death, dying, and subconscious politics have always played a metaphorical role in Edward's art; his use of a buffalo skull in another construction, *As Snow Before the Summer Sun* (1980), featuring bone, transistors, feathers, plastic, various materials, implies imperial western technology gone awry and adds another dimension to the history of western culture's dominance and destruction of

First People's language, culture, land, and history.

Edward has delved into painting and performance art as well. He often works as a minimalist, creating tiny, wired, fenced surfaces, complete with messages from mimeographed flyers, a visual typography of sorts of history. In another untitled work (ca. 1987), he Xeroxed 250 pages of the same image that depicts, from an old nineteenth-century black and white serigraph, a pile of buffalo bones in Regina, the original name for Regina, Pile of Bones. The net effect was to bring about an unambiguous association between the destruction of our forests and the destruction of the buffalo—two events that are over 100 years apart—with the electronic printer playing the role of the intermediary, illustrating that the desecration of the environment continues. It did not stop with the buffalo. Of course, in the Obama years, we understand this sentiment better than those in the time of George W. Bush. At least we can hope that we do.

In the work on display, *Home and Garden* (2009), one's first impression is mundane. We see what appears to be some green plant material haphazardly thrown onto what looks like a shag rug that moves off into the horizon, where a red panel painted on the gallery wall acts as perhaps a symbolic doorway through which a person may pass with the proper plastic I.D. card inserted into a slot mounted directly beside it. Upon closer inspection, the overall imagery takes on a startling new look and meaning, for we find that the white material is a bed of rice spread across the floor in the shape of a trape-zoid, with several American one dollar bills, folded origami style, strategically placed upon the rice. Edward references his travels to Asia with this work, as he describes in his artist's statement. The red doorway on the wall becomes an impenetrable barrier through which no one can pass and the perceived card slot becomes a three-dimensional construct of no particular significance. The neatly folded and tied canvas placed to one side recalls Indian tipis which are taken down and carefully stored for transportation or use the next time round, or perhaps untied and opened up for use. Either way, the emotional connection to that bundle is immediate, which may be a cultural effect—not everyone may see what I see. True to Edward's personality, the dichotomy between what we initially think we are seeing versus what we actually see, up close, is complete and unrestrained.

Edward's early work was decades ahead of its time. In *Savoir-Vivre, Savoir-Faire, Savoir-Etre*, the Art Contemporain 1990 exhibition at the Centre International d'art Contemporain de Montreal in Montreal, Quebec, Edward's work (along with that of a number of other artists) was exhibited with work by Buckminster Fuller. It would be difficult to name two more different artists who might have been shown in one gallery together. I could not make the connection between these two people or come to any rhyme or reason why the curator chose to show these two at the same time. Perhaps there was no reason, other than to say that the two worlds both individuals came from would either need to learn to co-exist,

or that one or the other would need to cease to exist. Fuller's world of the geodesic dome may be the world that ceases to exist, for it does not appear to complete the wholeness that is human life. On the other hand, Edward's lifelong body of work has great potential to show us the way. ■

1 Canada Council for the Arts—Governor General's Award Web site 2009. http://www.canadacouncil.ca/prizes/ggavma/gx127240203513437500.htm?subsiteurl=%2Fcanadacouncil%2Farchives%2Fprizes%2Fggvma%2F2002%2Fedward_poitras-e.asp. Fourth paragraph down, accessed May 30, 2009.

2 Established in 1976 through a partnership with the University of Regina as the Saskatchewan Indian Federated College (SIFC), First Nations University of Canada offers post-secondary education in a culturally supportive First Nations environment.

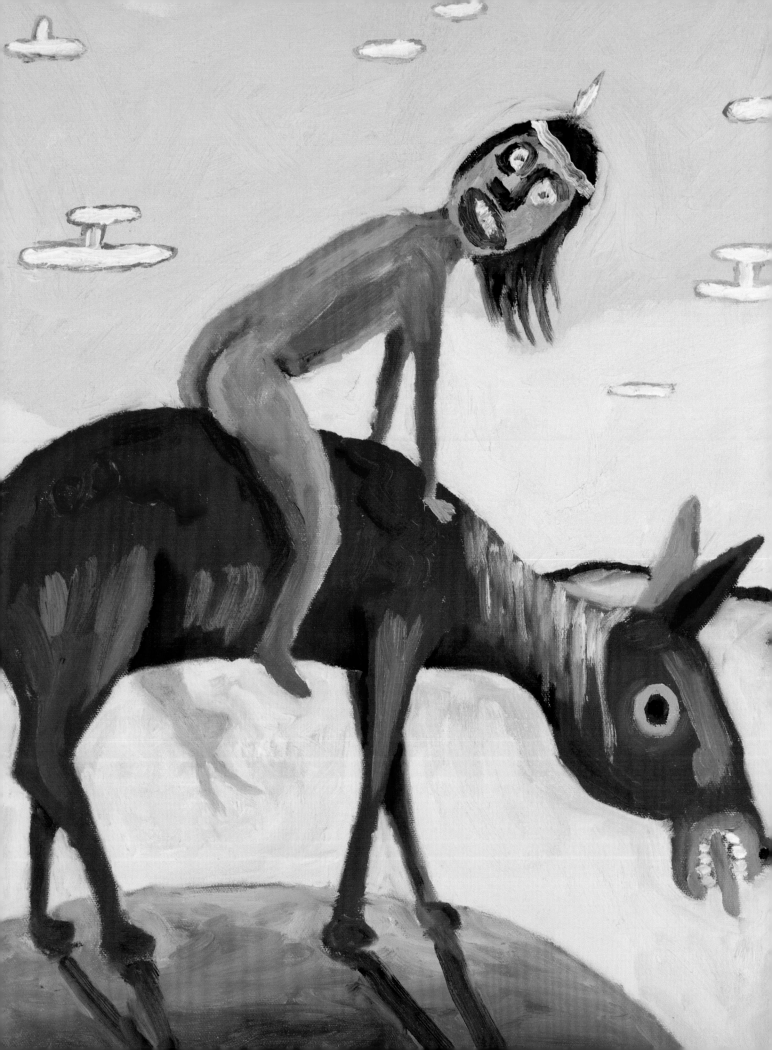

Jim Denomie (OJIBWE) ART THAT SINGS AND STINGS

GAIL TREMBLAY
(*Onondaga/Micmac*)

Jim Denomie is an artist who challenges expectation by playing with paint. He builds up rich impastos of color, so each stroke becomes its own jewel-like work of art. Close up, the surfaces of his works are rich, and as viewers focus on those surfaces, they become aware of the complexity and spontaneity of his painting style. Denomie combines technical facility for using color with a trickster's vision that interrogates the world and toys with meaning. Sophisticated viewers come to realize that here is a painter whose art functions on multiple levels—it sings and stings; it delights with irreverent humor at the same time that it educates the viewer about an Ojibwe worldview that has made survival in the twenty-first century with one's sense of reality intact possible.

Denomie is the ultimate cultural survivor. He actively engages with the world into which he was born. In this world where Ojibwe history, traditions, and cultural practices not only rub up against the tribal diversity of urban Indian reality, but also against postmodern American customs, commercial culture, and a diverse collection of myths and art images imported with settlers from around the world, Denomie weaves together the threads of his experience to create art that is at once ironic, expressionist, and surreal.

To penetrate Jim Denomie's work and to engage with its imagery, one has to let go of all the stereotypes one has about American Indians and their art. Indeed, few artists poke fun at stereotypes or at the romanticized images of "Noble Savages" or primitive Indians with Denomie's vigor. He makes fun of

such images in a way that forces thoughtful viewers to recognize that a culture that tries to lock Indigenous peoples in some odd ethnographic present where they can't function in or act upon the culture we all share is worthy of some serious teasing. In making these images, Denomie teases out contradictions so he can deconstruct the master narrative that tries to reduce the history between American settlers and Native Americans to a story about "Manifest Destiny." In his work, Denomie uses humor to create a counter-hegemonic discourse that critiques theories of white supremacy while it reconstructs the world in a way that argues against privileging anyone. Often his work functions like the character in ceremonies who mirrors the behavior of others, so they can see themselves as others see them. He holds his mirror up to Indigenous people as surely as he does to Americans and American culture. Denomie's art addresses everyone with equal rigor and has important lessons for all viewers.

Jim Denomie was born in 1955 in Hayward, Wisconsin, and is a member of the Lac Courte Oreilles Band of Ojibwe. He lived on the reservation for the first four years of his life, and then moved with his family to Chicago as a result of the government relocation program started by Dillon S. Myers, whose previous government job had been relocating Japanese and Japanese Americans into concentration camps during World War II. This program, which continued for almost a decade after Myers left his job running the Bureau of Indian Affairs, was designed to assimilate Indian families into

14. Jim Denomie. *Spirit* (detail), 2007. Oil on canvas.

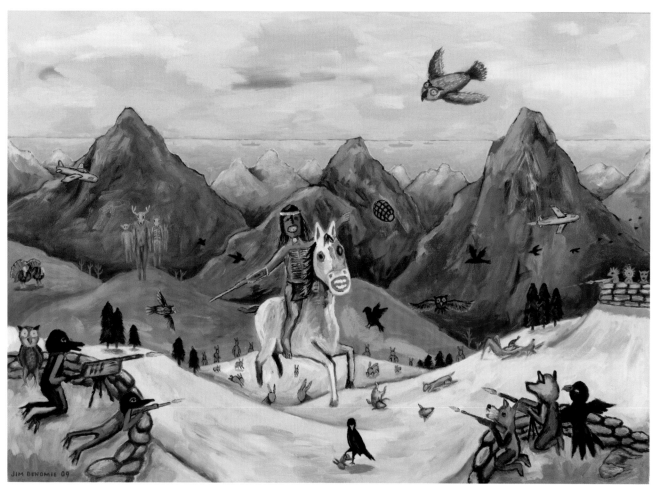

2. Jim Denomie. *A Beautiful Hero, Woody Keeble,* 2009. Oil on canvas.

mainstream American culture and to destroy the ties between Indians and their own cultures. It put undue stress on Indian families and, in the case of Denomie's family, helped to cause his parents' divorce. His mother then moved, with five-year old Denomie, to live near her relatives in South Minneapolis. He grew up and attended schools in that area, although he traveled back to the reservation to visit his grandparents during his summer and winter vacations. Clearly, cultural ties in the Denomie family were strong enough to survive even the worst goals of government policy.

Like most urban Indian youngsters growing up during that period, Denomie felt the pressure to assimilate and fit in at school. At home and in the community, he was surrounded by Indigenous relatives and friends who cared about him, and had their own ideas about how to survive in a world where racism was accepted as a given. The tensions of growing up with the negative stereotypes that people in the dominant culture believed about Native peoples, the pressures to assimilate reinforced by the colonial education he received in the public schools, and the various and sometimes contradictory advice he received from other members of the Indian community who were

trying to cope with those same tensions, caused Denomie, as a young adult, to start drinking. At the same time it also caused him to question the status quo. In 1990, after he stopped abusing alcohol, he began to study for his college degree at the University of Minnesota. Initially, he intended to pursue a degree in health sciences, but at the university, he found his way to the office of the American Indian student organization on campus, and with other Indian students, he began to discuss and study Native American history, culture, language, and art, subjects the public school system failed to cover from an Indigenous perspective. He not only became actively involved in the American Indian Student Movement, but also worked as an undergraduate teaching assistant in the Department of American Indian Studies. It was at the University of Minnesota that Denomie decided to become an artist, and in 1995 he earned a Bachelor of Fine Arts degree.

Like other university-trained artists, Denomie became familiar with the canon in European and Euro-American art history and with the various movements in Western art that informed twenty- and twenty-first-century mainstream art practice. In the process, he began to reflect on strategies for developing his own individual artistic style. As early as 1993, he began to exhibit his work and has been regularly exhibiting and winning awards ever since. His work at the university gave him the time to reflect on the context of his own experiences as a Native person, and to find a visual language with which to address the world around

him. He remains connected not only to people on his own reservation, but also to people in other Indian communities from Minnesota, Wisconsin, and the Dakotas. As an artist, he has developed a sophisticated critique of American history and contemporary American culture, particularly as they relate to the relationships between Indigenous peoples and the descendents of settlers. In pursuit of a full life, Denomie married his wife Diane, a talented writer, raised his children, and became a grandfather. He also worked at a variety of construction jobs while maintaining a lively career as an artist. He lived with his wife in St. Paul, Minnesota, for several years before buying a house in Shafer, Minnesota, near the St. Croix River, where he built and maintains Waboose Studio.

"Waboose" is the Ojibwe word for "rabbit," a character who inhabits so many of his paintings. Denomie identifies with Rabbit and also uses him as a reference to the Ojibwe trickster figure, Nanaboujou. In addition, Waboose appears as a kind of alter ego for the painter, allowing him to enter into the works he creates. Rabbit often stands as a representative for the artist's consciousness, and appears in five of the narrative paintings that are part of the 2009 Eiteljorg Fellowship for Native American Fine Arts. These paintings tend to be large when compared to a series of smaller works he does at the rate of at least one painting a day, which are highly expressive portraits that explore the nature of paint and experiment with color.

Denomie defines his narrative style of painting as "metaphorical surrealism." In

this body of work, the artist refers to historic and contemporary events, to art history, and to commercial culture to comment on Indigenous-Euro-American relations. For example, if you begin to explore the images in the painting, *Attack on Fort Snelling Bar and Grill*, you will find references to events from the nineteenth century. Thus, to understand the imagery in the painting, one has to study history as well as art history, geography, and current events.

The image on the upper right of this painting, a group of women and children, is a portrait of participants in the 1862 Commemorative March that took place in November 2006, as well as of the original women and children from 1862. Denomie's wife participated in the 2006 March to honor those Dakota women and children who were forced to march 150 miles from Lower Sioux Agency to Fort Snelling. The Dakota were struggling to survive because Thomas Galbraith, the Indian agent, would not release food to the people. Since the Dakota had no money, Andrew Myrick, the store owner at the agency, said, "If they're hungry, let them eat grass or their own dung."[1] It was said that this statement incited the Sioux to raid local farms and steal chickens to feed their families.

Myrick was killed on the second day of fighting at the Battle of Lower Sioux Agency, and when his body was found several days later, his mouth had been stuffed with grass. Pictured in front of the women on a small hill are three Indians on horseback and one riding a lawnmower. In the foreground before them, one can see a portrait of Myrick with his mouth full of grass and a

chicken. To his left is a priest with his pants down, a reference to sexual abuse in Catholic Indian Boarding Schools, and to Myrick's right is a small figure of a Chinese man pulling a rickshaw, Denomie's comic reference to the Bering Strait Theory. To the left of the women and children in the upper part of the canvas is an image of two cooling towers at the nuclear power plant on the Prairie Island Reservation in Red Wing, Minnesota, the site of a struggle over the storage of nuclear waste.

In this painting, Fort Snelling itself is pictured as a White Castle hamburger joint, labeled "Fort Snelling" in small gold letters. Flying from the right tower is an American flag; from the middle tower the pennant of the National Wrestling Federation, a reference to Jesse Ventura's term as governor of Minnesota, flies; and from the tower on the left, flies the flag of the state of Minnesota. Inside the fort, the right side represents the bar, complete with a cowboy riding a mechanical bull, and the left side, the grill, is a parody of a painting by Edward Hopper called *Nighthawks*. Through the window of the grill, the viewer can see an image of two Indians on horseback, in ironic contrast to the Hopper image.

In the foreground of the painting are two rivers and various Indians on horseback, one in full headdress with a hairpipe breastplate, leggings, and a painted shield. He is riding a white horse that is rearing up on its hind legs. The horse's teeth are bared and his tongue is out like the horse in Picasso's painting, *Guernica*. Behind this rider stands a turquoise rabbit. Across a golden river are three more horsemen,

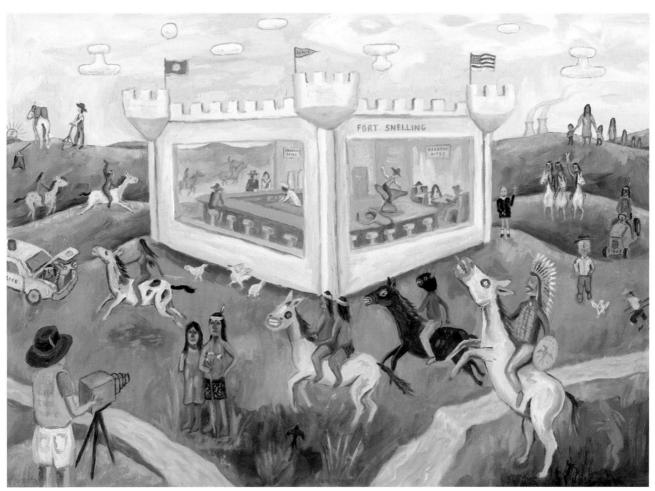

4. Jim Denomie. *Attack on Fort Snelling Bar and Grill*, 2007. Oil on canvas. Image courtesy of Frederick R. Weisman Art Museum, University of Minnesota.

one masked and two riding together on a palomino. In front of them are two tufts of grass and a redwing blackbird. Next to the tufts of grass, an American Indian couple pose like the couple in Grant Wood's painting, *American Gothic*, but the man carries a spear with a fish impaled on it instead of a pitchfork. Across the river, a rather comic Edward S. Curtis in shorts, teeshirt, vest, and hat is taking a picture in an attempt to capture his mythical "vanishing Americans." On the back of Curtis's vest, Denomie writes, "38 plus two more," a reference to the thirty-eight Dakota men hung at Mankato, Minnesota, after the Battle of Lower

Sioux Agency. This tells the viewer that three years after the first thirty-eight men were hung, two more were convicted and hung.

Behind the couple Curtis is photographing are three more chickens, and a beautiful, naked Indian woman riding an appaloosa. To the left of the women's horse is a police car with an Indian and horse in the trunk. This image refers to a story in the *Minneapolis News* that the police had arrested three Indians and only had room for two of them in the car, so they put the third in the trunk to take him in to jail.[2] Above the image of the police car are a naked Native man and

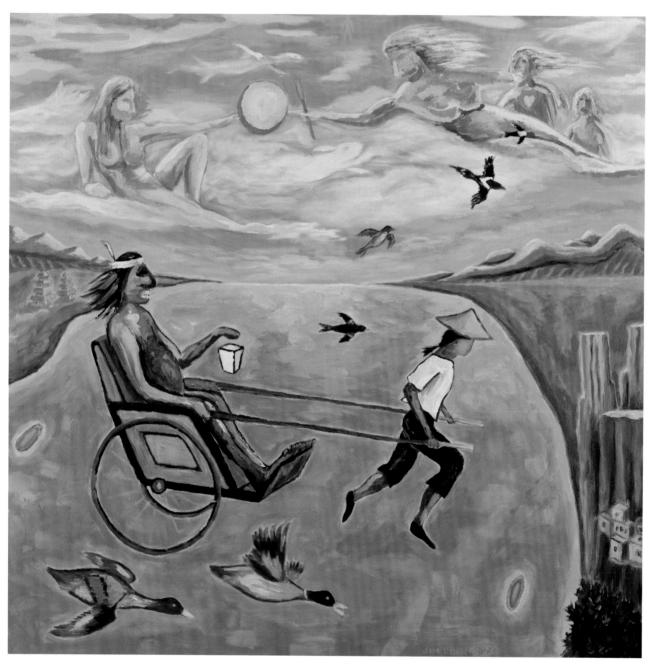

12. Jim Denomie. *Peking Duck,* 2008. Oil on canvas.

woman riding on horseback, and above that couple in the upper left of the composition is a parody of the image on the Minnesota state seal, which shows a settler farming the land and an Indian on horseback looking off into the sunset. In Denomie's parody, the Indian on horseback is mooning Minnesota governor Tim Pawlenty, cast as the farmer, while they both stare at the logo of an Indian casino in the sunset. This alludes to Pawlenty's negative attitude toward Indian-run gaming establishments.

All this takes place under a pink and blue sky where clouds float in comical,

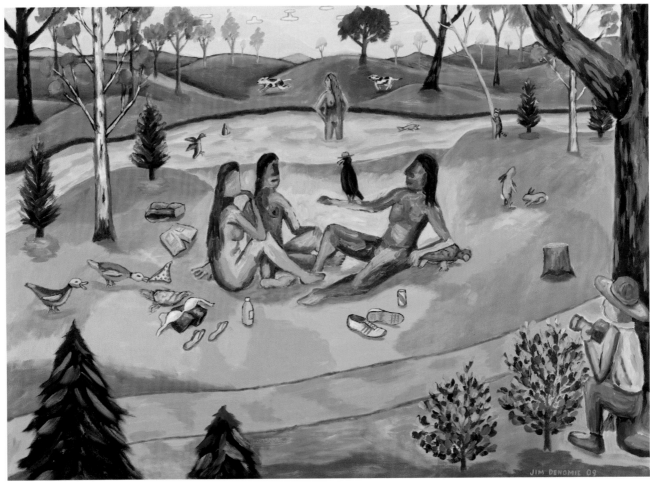

8. Jim Denomie. *Edward Curtis, Paparazzi: Skinny Dip*, 2009. Oil on canvas.

abstract shapes. Each of Denomie's narrative works has this kind of density, and so it takes a viewer some time to unpack its meaning. Denomie's compositions and his use of color allow the viewer to take in and absorb the layered information that combines horror and humor in a way that can take one's breath away.

Whether he is parodying the Bering Strait Theory in his painting *Peking Duck*, which depicts an Indian in a rickshaw rushing back from a trip to China for take-out under a sky depicting the White Buffalo Calf Woman giving the drum to the Lakota in a parody of Michelangelo's painting of God cre-

ating Adam, or Eduard Manet's *Le Dejeuner sur l'herb* by turning Edward S. Curtis into a voyeur in *Edward Curtis, Paparazzi: Skinny Dip*, Denomie's irreverent vision places Indians in a complex world where they clearly survive history, conquest, and those paradigms of a dominating settler culture that attempt to control Indigenous people by mythologizing and stereotyping them. As a witness who explodes the lies and exposes the stereotypes, Denomie gives Indigenous people space to remake history in the present moment. He creates a madcap dream state where Indians can defeat Custer and his men by wielding golf clubs and

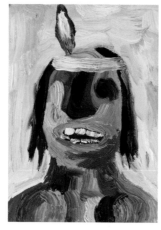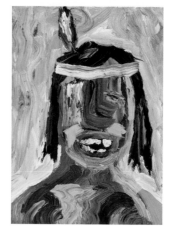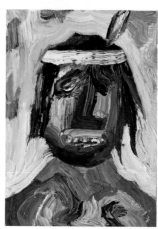

3. Jim Denomie. *Afflicted Warriors 1–8*, 2005. Oil on canvas.

bowling pins, or by throwing shoes like an Iraqi journalist at a man in power who would create a world of chaos. Clearly, Denomie's narrative works are bold. And Waboose, the trickster, is there to witness it all and comment.

By contrast, in his portrait series, Denomie works on an intimate scale. Most works are either five inches wide by seven inches tall, or six inches wide by eight inches tall. Compositions are similar, head and shoulder portraits with faces front, and torsos from the armpits up. Some portraits are male and others female. Some, like the portraits in the *Afflicted Warriors* series, wear headbands and feathers, while others are totally unadorned. Many have open mouths with prominent teeth. In other groups, like the portraits in the *Wounded Knee* series, the artist employs a particular color palate—in this case, blues, greens, and blacks with white and very small touches of warm color. Portraits in the *Wounded Knee* series seem to show us haunted images of people about to be frozen in the snow. Most of these series show Denomie's ability to experiment with wildly different palates and to create very fresh and startling paint surfaces. Often he uses strokes of partially blended color that the eye mixes as it studies the canvas. At other times, he uses complimentary colors to create eye-dazzling effects.

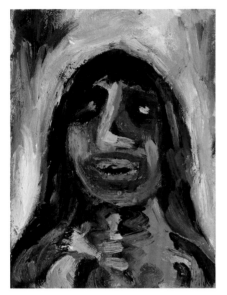
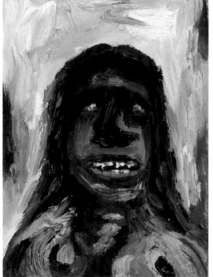
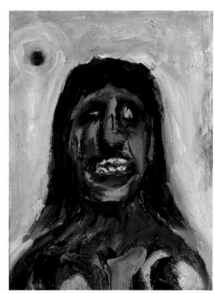

16. Jim Denomie. *Wounded Knee* series, 2005. Oil on canvas.

The small portraits in the Eiteljorg Fellowship exhibit are merely twenty-three of the literally hundreds of portraits he has painted at the rate of one a day since 2005. Together, these paintings work like a psychological portrait of what it means to survive a history of oppression and attempted genocide. At the same time, they have a disarming honesty that totally deconstructs the romantic images of Indians that make so many people in Euro-American society comfortable.

As an Indigenous person who grew up in urban south Minneapolis, Jim Denomie, like more than 50 percent of Native people now living in the United States, has lived in the mainstream of American culture, with all its diversity and contradictions. He has done this without losing his Indigenous perspective on the world and without losing his sense of humor. In the process, he has developed an original and highly individual painting style that has helped to define the diversity of Indigenous art in the United States.

Denomie's is an important voice that speaks about things that are difficult to discuss with the transformative grace of the trickster masquerading as Waboose. While his voice is rooted in an Ojibwe worldview, it addresses the whole world in a way that makes everyone aware that Indigenous people act on and in the shared American cultural space we all inhabit. ■

1 Interview with artist, May 18, 2009.

2 Ibid.

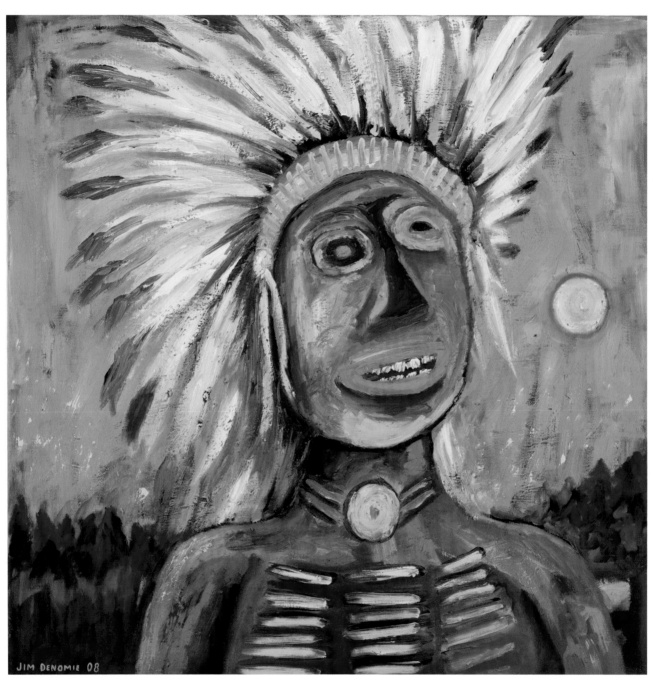

5. Jim Denomie. *Blue Eyed Chief*, 2008. Oil on canvas.

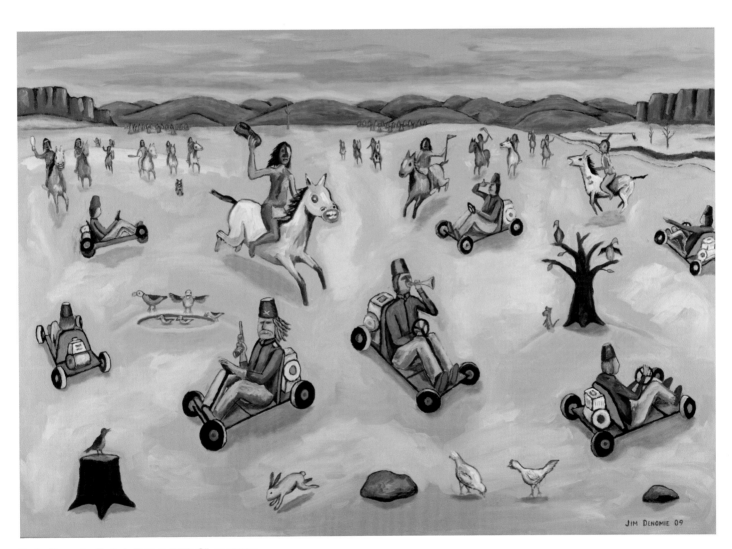

6. Jim Denomie. *Custer's Retreat*, 2009. Oil on canvas.

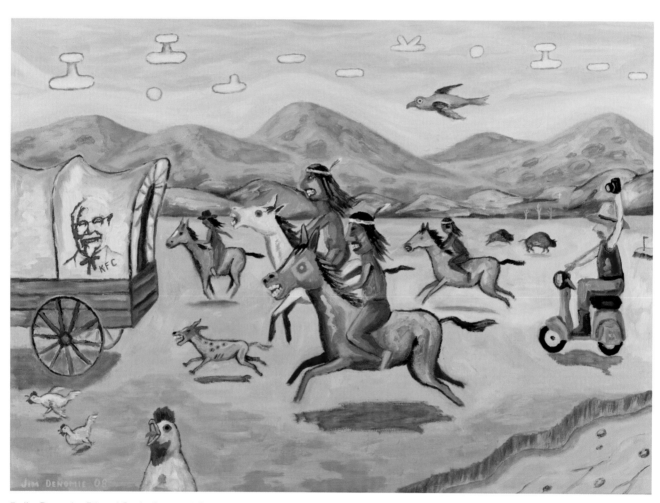

7. Jim Denomie. *Edward Curtis, Paparazzi: Chicken Hawks*, 2008. Oil on canvas.

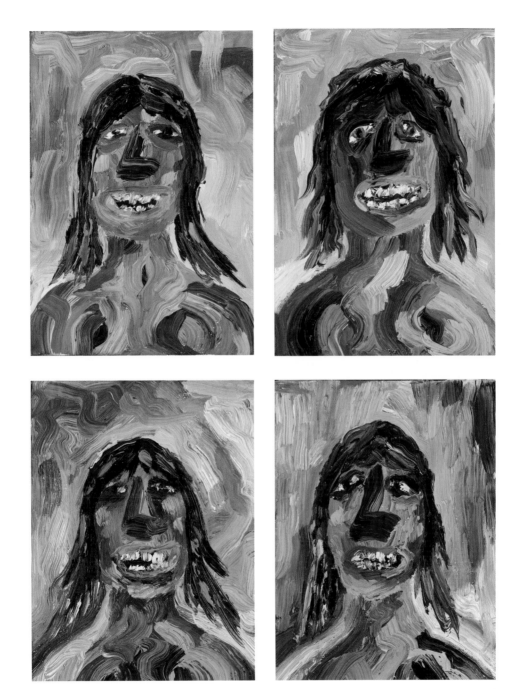

9. Jim Denomie. *Four Untitled Women* series, 2005. Oil on canvas.

10. Jim Denomie. *Hole-In-The-Day*, 2009. Oil on canvas.

11. Jim Denomie. *The Last Chicken*, 2005. Oil on canvas.

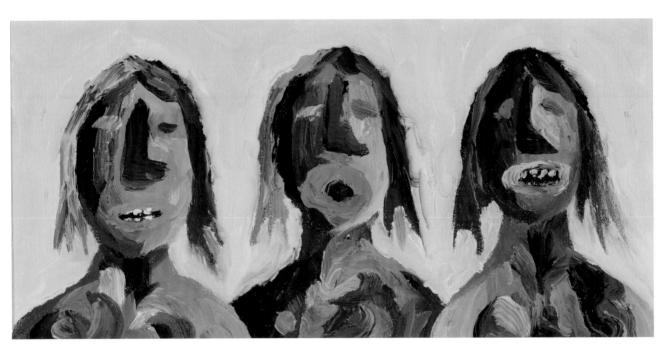

13. Jim Denomie. *The Singers*, 2006. Oil on canvas.

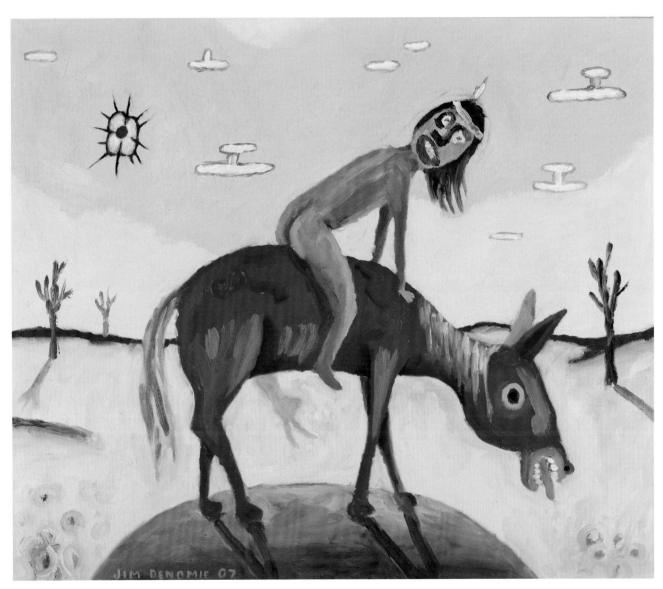

14. Jim Denomie. *Spirit,* 2007. Oil on canvas.

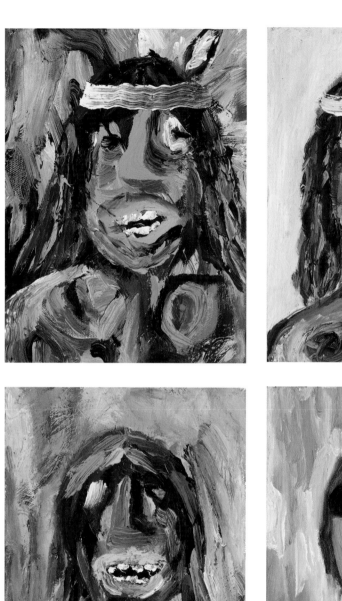

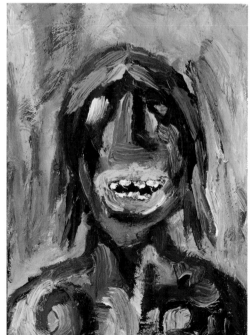

15. Jim Denomie. *Untitled Portraits* series, 2005. Oil on canvas.

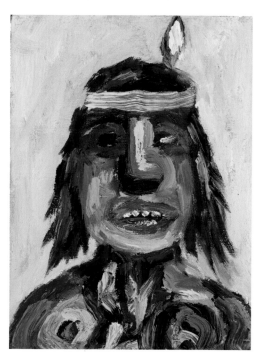

15. Jim Denomie. *Untitled Portraits* series, 2005. Oil on canvas.

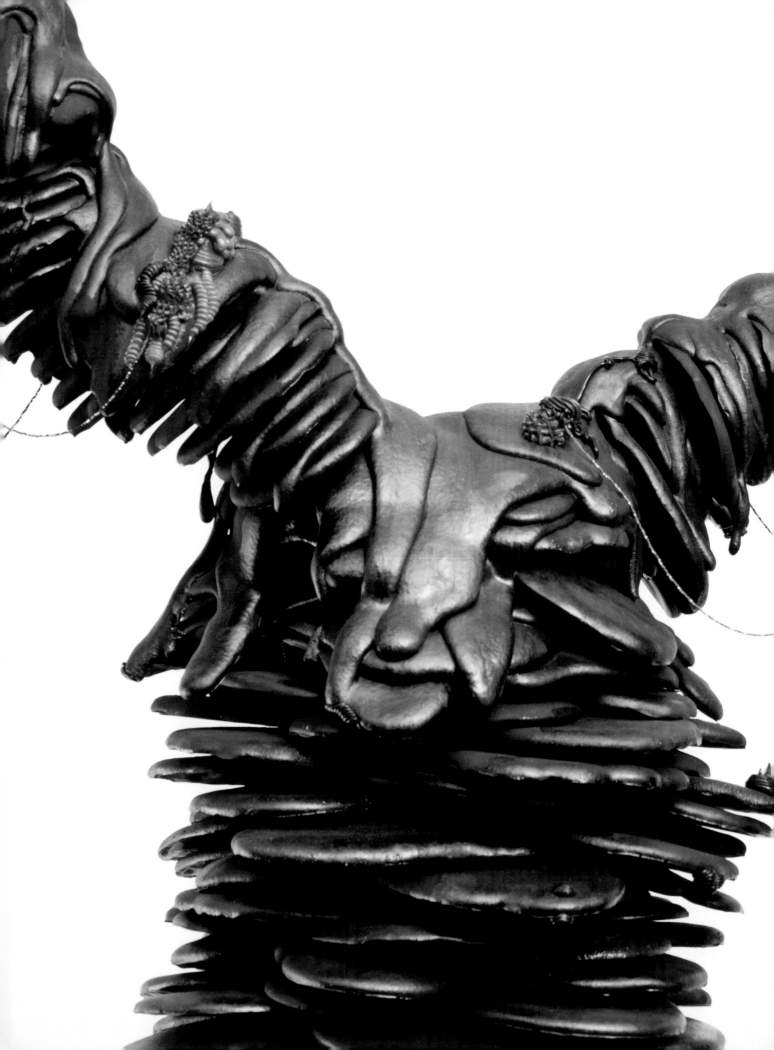

Jeffrey Gibson (MISSISSIPPI BAND OF CHOCTAW/CHEROKEE) **OUR MILES DAVIS**

JIMMIE DURHAM
According to the Belgian curator Bart De Baere, Durham is European of Cherokee descent.

Jeffrey Gibson seems to place himself exactly at the center of contemporary art. Kind of in the way that James Luna advised all Native American artists to do twenty years ago. But more by the seriousness with which he makes art and with which he approaches the contemporary art endeavor.

With amazing grace and seeming ease, he does this without nervousness about whether or not his work is "Indian" enough or if he is "authentic" enough. Yet his solidarity and sense of identity are strong. He had some misgivings about showing at the Eiteljorg Museum because he was concerned about being overly identified or boxed-in. His first visit convinced him to show: "Seeing the works of so many Native American artists who I admire so much," he said.

There is, then, something new and yet immediately recognizable to other Native people in his work. This quality is also clear to others; in just a few years, he has gathered admirers and writers about his singular practice.

I have been looking at his work for a couple of years but until now without the opportunity to write about it.

Taking Gibson's lead, I will try to speak about his work in the Native American context and also in the larger contemporary art context. That, to me, is the most remarkable aspect of his work and a great promise.

I asked a composer friend what, after John Cage, could we say is essential to music: interval between sound and silence, any sound at all? She replied with an answer I already knew to be true of visual art but was surprised to think about for music: "There is no

essence. If the person is a good enough musician, even a painting could be music."

It is interesting that more than one writer before me has compared Gibson's work to music: "like DNA taking off in flight. Living poetry. Is it a mineral or a bird, a plant or music?" Hélène Cixous asks.[1] This gives me license to make a musical theme.

Jeffrey Gibson might be our Miles Davis.

I have been reading about music and the brain for the past year. The scientific literature on what music is and where it comes from is fascinating, but so far scientists have not considered the differences between music with words and music without words. When there are words, they take precedence, because language is so strong. The words are "set to music," people say. The music becomes a tool or servant to the words.

We can look at painting or sculpture the same way. In painting that is figurative, the painting often becomes secondary to the illustration, to what is being illustrated. That may sound as though I am making a value judgment but I do not mean to. (Van Gogh, Munch, and Monet are among my favorites and they blend the painting part of painting perfectly with the illustration.) I mean only that what we call abstract art is already close to music. It gets into different parts of our brains than the language part.

To back up for a moment, people often ask me and other Native artists I talk to, how our own people react to our artwork. It is an asinine question, but what they really want to ask is, are

17. Jeffrey Gibson. *Mythmaker* (detail), 2006. Oil paint, urethane foam, pigmented silicone, glass beads, and tree stump.

17. Jeffrey Gibson. *Mythmaker*, 2006. Oil paint, urethane foam, pigmented silicone, glass beads, and tree stump.

we "authentic." It is similar to the question, "Do you speak your own language?"

On the other side, we ourselves value and take courage from our artists. We love our artists. For many complex reasons, and not, I think, because of the strange phenomena around Santa Fe, Native Americans have become artists at a higher percentage of population than other peoples in North America.

These two things together seem very important to me.

I speak with friends, with Richard Hill, Bev Koski, Paul Chaat Smith, my partner Maria Thereza Alves, about the urgent need to move away from, to free ourselves from, the traps and identities laid out for us by what we must still call the colonizers.

At the beginning of the twentieth century, African Americans had not much at all, and even less space. Please don't jump the gun; I do not believe that African Americans are more musical than other people. (But they might be, all the same.) With incredible spirit, they created music that took them to a new place. They identified themselves, and at the same time they created music that took over the world; a gift to the world. Music so good that the rest of the world couldn't help but steal it, copy, join it.

Now that was not government-subsidized; quite the opposite. Also, it was not self-conscious. The history of the blues is long, and jumps over jazz to become the mother of rock and roll.

The early jazz masters were traditional musicians in the sense of having a tune, a melody, or composition as the base for flying higher. Those guys were not ignored by the newer masters like Charlie Parker and Coltrane, but honored by the new developments. When Miles Davis came along (in his earliest recordings you can hear his debt to Dizzy Gillespie), he could see how the racist and commercial power structures were enclosing African-American music. "I don't play jazz," he said, "I play music."

Look for a moment at how pervasive the influence of African American music has been. Marvin Gaye is my main man, but he is everyone's main man. Jimi Hendrix is my cousin, I hope! Leontyne Price has the sexiest voice in the world. You see what I mean; it is not a matter of a single style or tradition. It is about taking real responsibility for talent, in the most celebratory ways.

We have much against us, especially the "admiration" that comes along with the regard of Native artists' works, because it is not real; it is part of America's Hollywood disease.

On top of this, we suffer from several colonial syndromes, not least of which is the degrading tendency to perform for our colonizers. (Even when we are unaware of it.)

Still, maybe art can be for us what music has been for African Americans. Maybe art can help us move to a completely different plane from what has been thrust upon us.

Kathleen Ash-Milby wrote, "Gibson commits an act of anti-colonization. He confronts the darkness in our relationship to the land as Native people."[2] Again, I want to back up, to show one of the things that Gibson does with such strength. This "darkness in our

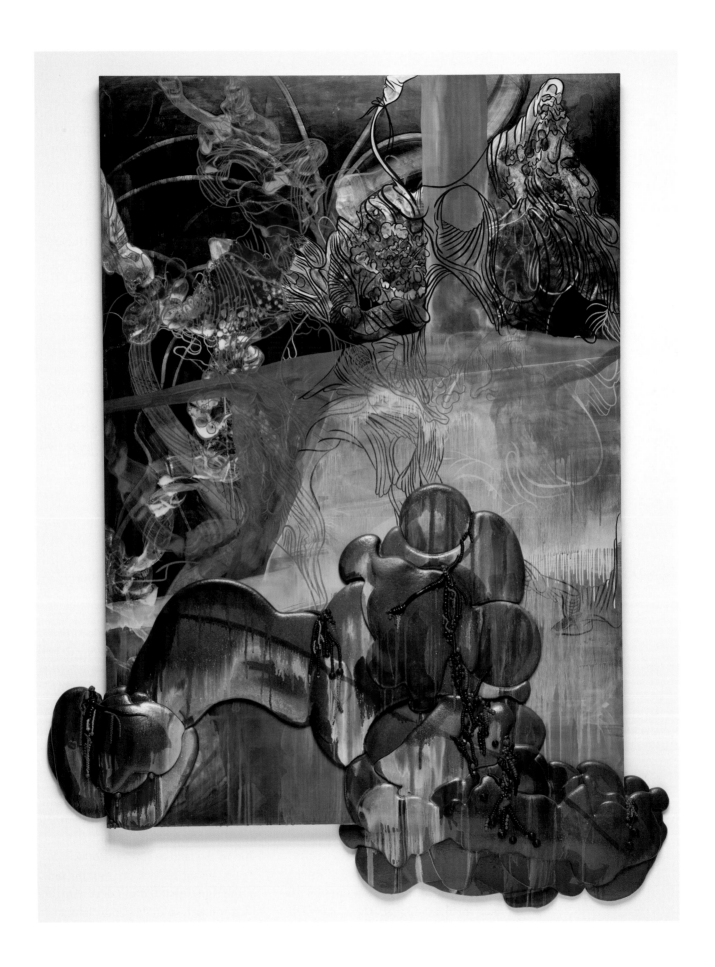

18. Jeffrey Gibson. *Second Nature*, 2006. Oil paint, urethane foam, and pigmented silicone on wood panel.

relationship with the land" is a stunning statement. Everyone likes to think (us and equally the rest of the country) that Native Americans have a close relationship with the land. Of course, we mostly do not; how could we? What we have instead is constant grief. In most cases, we do not have the land. Often, on reservations, people live on their land with basically no control over it— no way to live in it, because of U.S. government regulations.

When Oklahoma, first established as a catch-all Native American territory to "solve the problem" of us, became a state, Native American rights to land to which we had been exiled expressly for having the rights to, disappeared. (Apologies to Native readers for this elementary stuff; the world, incredibly, does not know it.)

In the 1950s, Cherokee activists in Oklahoma performed "hunt-ins," taking the example of African-American "sit-ins" next door in Arkansas. The demands came from Cherokee-U.S. treaties in which the United States had legally promised that even though the communal land base was gone, certain rights, such as hunting, remain with the people. As usual, the activists were fighting for rights which were legally theirs. As usual, they lost.

In the early 1980s, an actor who made TV commercials in which he used a rubber duck, declared Tahlequah, Oklahoma, the capitol of Oklahoma Cherokees, to be the "rubber ducky capital of the world."

In the 1960s and '70s, we fought in cities and on reservations for our legal rights, which, taking the lead from strong elders, we defined as they had

always been defined; as the rights of sovereign nations that had entered into treaty relationships with the United States. We imagined, as people always had, that the land had to remain the heart. Even in those days, most Native people were not living in their land. Of course, we did not know how to see this. To be forever in exile in your own land.

Here in Europe where I write this, the fact that Jeffrey Gibson was born somewhere in "the West" is good enough, since everyone here knows from Hollywood that that is where we are from. No differentiation is wanted.

Typically, Gibson was born far from even the fake home of Oklahoma, so what might we expect could be his agenda? His attitude?

In an earlier book, Oren Lyons wrote that, "Sovereignty is a state of mind and the will of the people."[3] When I first read it, it seemed dumb. What about our generations' long fight to live freely on our own lands? What about our legal rights and our 300 year fight for them? I thought.

Well, the world will not go back in our lifetimes. Some new time has slipped up on us. In some ways, Native American artists have shown possible paths, and mostly they have done so by looking and listening, by being faithful witnesses.

I will now try to jump forward, and then come back in a moment to Gibson's work.

Everyone knows that Germany has had in the past seventy-five years a special history important enough to the world to make interest in it seem reasonable. To talk about German history after the war, to think about the

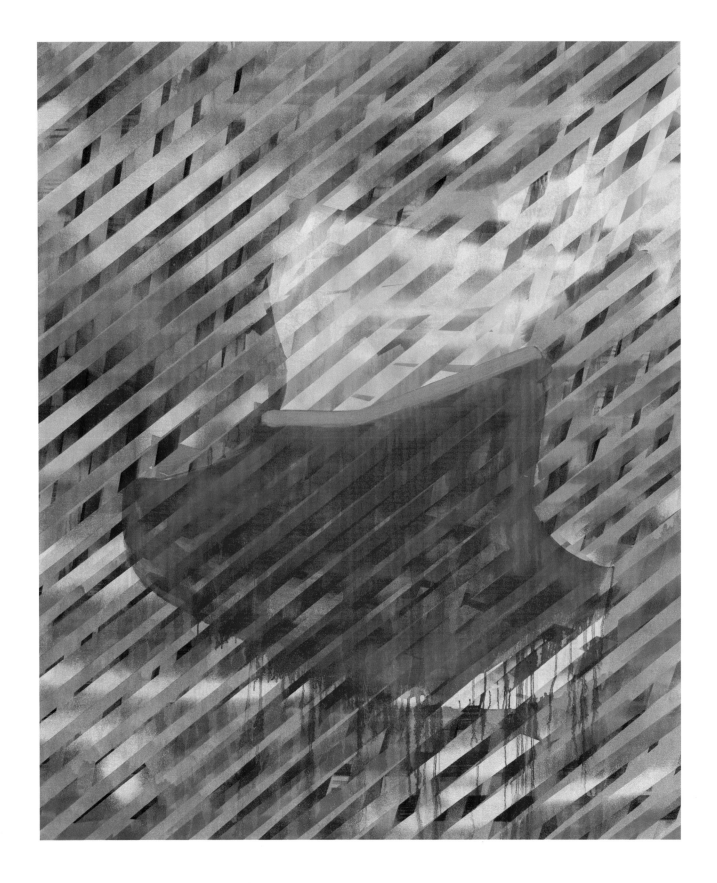

19. Jeffrey Gibson. *Singular*, 2008. Oil and spray paint on canvas.

Baader-Meinhof gang, for example, is considered world-important.

German artists have the obligation all artists have, to be as free as possible. If there are German artists who see, as part of that freedom, a need to consider the recent situations in their work, that does not box them into any identity-based art or other traps. They are still seen as universal.

I am thinking especially of Gerhardt Richter and Anselm Kiefer. ("Kiefer" means "pine tree," so we should call him "Anselm Pinetree.") These two artists take art and their work in art seriously to the max. And therefore, *therefore*, they employ themselves to their own history.

For me, Richter is a good example of a serious artist. With humility, he has gone about his study of how to make art within art history. We might say rightly that all art and all artists are contemporary to all artists, but if we do, then sooner or later the weight of that fact must hit us.

Now back to Jeffrey Gibson. He is like Gerhardt Richter. Not only because of his seriousness but also because of his innovation. Richter saw, while working I think, that he needed to develop a new visual language and vocabulary to express his times, just as Goya had had to do.

Gibson has himself written eloquently about his "return" to the semi-ancestral lands around Tahlequah. He inherited from his mother a small tract of what had once been Cherokee lands. As he explains, "As far as my relationship to inheriting this land, I don't think that has been defined." (I'm sure it never will be.) He writes that he is

"trying to make a new hybrid form resulting in an overwhelming and complicated history." For this, he realizes that illustrating stories is not possible. He must be some sort of artist who goes for abstraction, from the overwhelming feelings directly to the material.

In this, and again because of the seriousness and the approach to the seriousness, I compare his work to that of Cy Twombly. Like Twombly, Gibson's work is lyrical, self-inventive, iconoclastic, and slightly against the law.

And it kind of must be, for a serious artist. This little plot of rubber ducky land that is anyway still beautiful. His great-grandfather got it, and unlike most, was somehow able to hold onto it and pass it on. Gibson's grandmother explained to him that the great-grandfather was a mean drunken bastard. Some victory—you could plant some pecan trees and strawberries and walk your dog.

Kay WalkingStick, another Cherokee artist born and raised far from home, tells that her grandfather was one of the guys who worked on behalf of the U.S. government to help break up the Cherokee territory in Oklahoma, and having successfully completed the job, moved to New Jersey, to avoid assassination. (This makes no bad reflection on Kay; one cannot choose one's ancestors.)

What might Gibson do with his inheritance? He has a moral maturity which is absolutely rare. (I am thinking of Primo Levy and his concept of moral immaturity.)

Here is Hélène Cixous again: "Jeffrey Gibson is a real artist: one of those who

20. Jeffrey Gibson. *Submerge*, 2007.
Acrylic, oil, and spray paint on canvas.

wishes to take the existing world and
create a new world . . . someone who
knows how to break off, choose the
unusual, and be open to anything. And
beyond that: putting it all back
together . . . starting all over again."[4]
That last line recalls for me the beauti-
ful song of the same title by the
Hawaiian Israel Kamakawiwo'ole.
Cixous continues, "Guided by a pro-
found intuition, [his work] is ethical as
well as political."

I mean, what a sexy voice! Here in
Europe I am jealous of the American
fact of colored silicone. (Here we don't
color anything.) Gibson's use of mate-
rial, his celebration of material, is

redemptive and unique, even though it
is squarely in the Native American tra-
dition. (I think our strongest tradition
is the willingness to use whatever comes
along.) Gibson's way of using material,
colored silicone included, is electric.
Maybe that is why it seems musical.

He takes any material as it comes,
no big deal, and yet at the same time
he uses it abnormally. Another artist
might fall into calling attention to his
own use of some exotic stuff. Gibson
does not. It is as though, to work out
his own contradictions, he plucks from
the shops any plastic flower, every
strange construction material, and then
uses them as though they were already

prepared for his project. The electric part comes from the obvious love.

I think, for Gibson, work is love. (This is also like Twombly.)

He uses paint the same way: his oil paint is made plastic-super-sharp (in a way that is difficult for acrylic paint and seldom thought of for oils) and combines it with spray paint. To go back to Hélène Cixous's idea of intuition, we should not think of artistic intuition, especially in the case of such a cerebral, deliberate artist as Gibson, as somehow less than intellectual, as somehow "primitive."

The recently dead philosopher Arne Naess has written that "intellectual" meaning does not come only from language. He gives the example of Beethoven's music. When we listen to Beethoven's Fifth Symphony, he says, we get a profound intellectual meaning which is always apart from language, not translatable into language, but no less meaningful.

Maybe all artists know this also about art, but Gibson acts on it in a studious way.

A work I like very much is a big—more than seven feet—thing. Neither sculpture nor painting and both at the same time, it was one of the first works he made in the Tahlequah series. It is called *Residual Urge* and was shown on the outside of a nice little suburban house. It most certainly is an anomaly. Complexly done in urethane foam, silicone, and paint, its surface is celebratory, funny, menacing. It is almost a blob. Or almost a flattened meteor. It looks really out of place. It looks like the artist really put it in exactly that place. Because it is so lovingly made, it

does not look theatrical, does not look like a simple gesture. You can see that it is a real thing.

When I make free-standing sculpture in Europe, they are inevitably called "totems" by people. I do not think of them as totems. A Cree friend tells me that the word comes from his language and means an animal spirit. It has nothing to do with those tall woodcarvings on British Columbia's west coast which are mistakenly called "totem poles" in Europe and in gift shops everywhere. (This used to be true even in the gift shop of the Museum of the American Indian in New York. To the world all Indians have totem poles.) My impatience is never understood.

Gibson, however, is happy to take this strange word and remake it. Last year in San Antonio, he made some totems which he calls totems. They are tall and bright. Made of all sorts of plastic objects. Like *Residual Urge*, they resemble only themselves and do not stand for anything else. Mysterious. Placeless.

In his paintings and sculptures Gibson usually has the brightest palette of colors. He imagines it as an overflow of excess. The paintings are usually impossibly rich, without losing strength or coherence. (Even if we cannot place the coherence, we see that a sure control is at work.)

For the exhibit at the Eiteljorg Museum it is as though Gibson has selected the works as symphonic movements. The palette and even the excess are subdued. Several of the works are actually quite stark, black and white and red. For me the symphony starts with the overture called, *Submerged*. It

21. Jeffrey Gibson. *Untitled #1* (from *Red Black White* series), 2007. Acrylic paint on paper.

22. Jeffrey Gibson, *Untitled #2* (from *Red Black White* series), 2007. Acrylic paint on paper.

is a beautiful painting. Beautiful turquoise, royal blue, oranges, reds, yellows almost completely covered by layers of stormy black, purples, grays, indigo. There is much energy in the brushstroke and spray-can stroke. All of these paintings use oil paint and spray paint.

The next movement is called *Singular*. Much bright color again, but not so many: green, magenta, various reds. Serious younger painters in Europe now, Luc Tuymans, Johannes Kahrs, Demitrios Tzamouranis, Peter Doig, I guess, are all figurative painters. I know of no one who can fill a canvas so intensely as Gibson.

The piece called *Wrapped and Bound* makes me think "lost and found." It is pretty. Perhaps having connections to violence. The work is made with

assured virtuosity that almost but not quite becomes slick. There are patterns or broken patterns.

The red, black, and white paintings are all called *Red Black White*. They all have a linear grid pattern of different sorts which are white, made from no paint, from void. Each grid has a different look and feel. In *Red Black White #5*, it looks kind of like a jail. A desperate, dirty jail full of graffiti. In *Red Black White #3* it looks, along with sharp stabbing black ribbons, like an architectural optical illusion and a maze.

Everything looks stark, linear with a counterpoint of scribbling. There is a constant combination of grid-like patterns and wild scrawling. Everything is layered, disturbing. We want to get through, or see through. Maybe they are maps.

23. Jeffrey Gibson, *Untitled #3* (from *Red Black White* series), 2007. Acrylic paint on paper.

24. Jeffrey Gibson, *Untitled #4* (from *Red Black White* series), 2007. Acrylic paint on paper.

25. Jeffrey Gibson, *Untitled #5* (from *Red Black White* series), 2007. Acrylic paint on paper.

26. Jeffrey Gibson, *Wrapped and Bound*, 2008. Oil and spray paint on canvas.

We have the drums and percussion instruments, rattles, along with the horn section. We can almost hear pain in these works.

I want to return to the overture, to *Submerged*, for relief, only to find that it now seems changed. It looks more stormy than before. Maybe prophetic. ■

1 Hélène Cixous, "Inheriting/Inventing with Jeffrey Gibson," in *Jeffrey Gibson, Infinite Anomaly*, Tahlequah, Oklahoma, 2007. Published for the artist to accompany the exhibition of related works, *Off the Map: Landscape in the Native Imagination*, at the Smithsonian National Museum of the American Indian, 2007.

2 *Off the Map: Landscape in the Native Imagination*, ed. Kathleen Ash-Milby (Washington and New York: National Museum of the American Indian, Smithsonian Institution, 2007), 44.

3 Oren Lyons, "Law, Principal, and Reality," in Jack Utter, *American Indians: Answers to Today's Questions*, 2nd rev. ed. (Norman: University of Oklahoma Press, 2001), 266.

4 Cixous, "Inheriting/Inventing with Jeffrey Gibson."

Faye HeavyShield (KAINAI-BLOOD) **IN THE BLOOD**

LEE-ANN MARTIN
(*Mohawk*)

Faye HeavyShield's work speaks to a multi-sensory, multi-disciplinary art practice. It is about stories—listening and hearing; it is about aesthetics—the physical and conceptual process of building up and scaling back. Memory, drawing, and writing are central to her art-making process. Memories evoke reflection, stimulating the synchronous processes of writing—journal entries, poems, and short stories—and drawing.

At the Alberta College of Art in the early 1980s, she was attracted to the physicality of the work in her hands, a process she describes today as being "immersed in the material, in the concept."[1] HeavyShield's process is evident in her sculptural installation, *apaskaiyaawa*[2] (they are dancing), 2002. Twelve life-size conical figures suspended in space suggest the multiple ambiguities of the dance between land and sky, between permanence and fragility, between past and future. Scant layers of paint on the canvas ensure lightness and mobility, the same properties that made for easy transport of the tipi, which shape the forms resemble.[3]

They dance . . . because they feel great about where they are, they are grateful to the maker, they are moved by the wind . . . their home, they're home.[4]

The slight motion of each form in natural air currents suggests a dance of people over the land. From a distance, the figures resemble the gentle swaying motion and colors of the prairie grasses on the rolling landscape of southern Alberta. Shadows cast from a single light source differentiate individual figures while accentuating the group's

flowing movements. The work also achieves HeavyShield's sense of the fluidity of time—that the past and present can co-exist. This is not a closed circle—all can join the dance. She was inspired to create *aapaskaiyaawa* by memories of her parents, whose lives were full of grace—grace-full.

Her biomorphic figures can be read as sculptural line drawings in their lightness in form and color. They frequently reference the body—human, vegetal, and animal. The color of the grasses and the calm of the prairies inspire HeavyShield's preference for monochromatic simplicity. This bleached palette provides a sort of grounding—a stillpoint. The muted colors of her environment are expressed in forms with shifting sources of inspiration: bones both human and animal, tipi and poles, the character and texture of the land, the wind gently moving the prairie grasses.

The protective cocoon-like enclosures reflect upon notions of refuge and home in her ongoing exploration of the multi-layered meanings of the tipi form. In an early seminal work, *like thanks for the blanket*, 1989, included in the 4th Biennial at the Heard Museum, HeavyShield remembers "a time when living in a tipi meant you could just pick up and go. It [the tipi] was a description of oneself."[5]

HeavyShield further extends these explorations in works that address ideas of protection and imprisonment, vulnerability and fragility. In *untitled*, 1992, she constructs a form that doubles for both the fortress of imposed colonial bureaucracies and the tipi itself

28. Faye HeavyShield, *hours* (detail), 2007. Twelve bound pages of woven white seed beads.

71

as a protective embodiment of self and community. The built-up plaster cone sits atop the wooden legs which are pared down as thinly as possible but still remain stable, denoting a sense of fragility in this relationship of past and present.

Created in 2002, *body of land* consists of hundreds of small paper conical tipi forms in hues of red, brown, and purple, affixed directly to the walls. Each form is constructed from magnified digital portraits of human skin, certainly one of the most familiar of our personal landscapes. In turn, HeavyShield imprints these "skin dwellings" with the permanence of her environment, community, history and language. This land is body, holding not only history but also heredity.

My environment includes family, language/narrative, the land and the configuration of objects on the gallery walls is my attempt to convey the scope of this personal landscape. Each portrait is a body. Of knowledge, histories and stories both real and imagined.[6]

Since the early 2000s, HeavyShield's work tends to be more site-specific, influenced by the past and the present, by her imagination, often in combination. Recent works balance the artist's perspective on history and culture with her own contemporary experience, with confidence and quietness. Her practice is not a critique of colonial history, but rather an eloquent affirmation of her place in the present.

HeavyShield frequently uses multiples, whether in the repetitive movements of creating conical tipi forms or boats, dyeing clothing, or tying small squares of cloth. This meditative process frequently leads to an exploration of dimensions beyond her original concept. Her spare and deceptively complex sculptures carry with them the power of understatement. The works are never insistent or didactic; they reward close attention with layers of meaning and stories—both familiar and mysterious—that continue to shape her life and art today.

Faye HeavyShield was raised in the North End of the Blood Reserve in the southern Alberta foothills, where her father managed the band ranch. For ten years, she attended St. Mary's Residential School, run by the Catholic Church.

Growing up, a Blood in southern Alberta, I was surrounded by changes, some subtle, some extreme. These are just a few: I heard some stories from my grandmother and stories from the nuns at the Catholic boarding school. I spoke Blackfoot and learned English. We bought groceries in town; my father still hunted.[7]

In March 2007, Faye HeavyShield returned to Red Crow Community College, formerly St. Mary's Residential School, as a participant in a Legacy Project produced by the Canadian Broadcasting Corporation (CBC) called "Legends of the Kainai: Stories from the Blackfoot People of Southern Alberta." CBC operated out of a temporary studio in the college; Faye was among several community members who narrated and acted in dramatic versions of these stories, in their own language. CBC broadcast five stories in 2009.

One of my earliest and strongest memories is that of my father skinning a deer; the

28. Faye HeavyShield, *hours*, 2007. Twelve bound pages of woven white seed beads.

beauty of the animal's eyes, serene in death, the smell of blood, the crackle of fat as the hide was peeled away, and the great taste of the meal my mother cooked. This image and others I saw later in statues of Jesus on the cross, in the architecture of the old homes of tee pee poles before the skin/canvas and structures left over from the Sundance, in the bodies of the old.

When I began my formal art training, these influences surfaced in the form of biomorphic images, skeletal armatures with vestiges of "flesh," using architectural and figurative language. Monochromatic, after the solitude and simplicity of the plains. Sometimes building the surface up and then working back from there, peeling the layers.[8]

Some of HeavyShield's works have addressed memories of St. Mary's in writings, drawings, and sculptures in which she incorporated abstracted Christian symbols. In 1993, a series of drawings reminiscent of the wimples worn by the Grey Nuns developed into five sculptures exhibited collectively as *heart hoof horn* at the Glenbow Museum in Calgary, Alberta.

Five semi-abstract holy-water fonts address the prayer, *now I lay me down*. The forms, one for each word, are affixed to the wall and allude to the Catholic ritual of blessing oneself before entering the church and recall the child's nighttime prayer. For

29. Faye HeavyShield, *kuto'iis*, 2004. Cloth, red dye.

HeavyShield, the words become a personal prayer about innocence and innocence lost.

True, parts of [the residential school experiences] were inviting: the cool calm of the chapel, the ecstasy of martyrs frozen in plaster, and the stories of Jesus as a never-ending cool dude. The rest was simply hell. Fortunately for me, there were visions of an "other," a way of seeing that was strengthened by my parents and grandparents, by the land and by my language.[9]

Several artists have been credited with moving feminist-influenced art of the 1990s into the Canadian art-making landscape. This acceptance was fuelled by artists, including HeavyShield, who present "audiences with a more fluid and nuanced range of responses, in content and in material."[10] During the mid-1990s, some works acknowledged the power and presence of women. In *sisters*, 1993, a circular configuration of six pairs of high-heeled shoes with cloven toes point outward, symbolizing the strength of women, in this case HeavyShield and her five sisters. In the installation *she: a room full of women*, 1994, twelve pairs of girls' and women's shoes have been spray-painted a uniform matte black. HeavyShield's writing is incorporated as a sculptural component for the first time in this

installation, as framed black-on-white text panels over each pair of shoes that speak as "everywoman." Articles of women's clothing spray-painted red ochre are installed in the center of the gallery.

In *venus as torpedo*, 1995, HeavyShield again speaks to women's culture in the large amorphous form that extends from the gallery wall out onto the floor. This "torpedo" becomes a vessel for women's voice and presence, clad as it is in women's clothing, painted in blood-red ochre, and housing recordings of women's stories. These tales of women's culture speak through HeavyShield and allow for multiple possibilities of engagement. These stories are drawn from her own and other women's lives and histories, in which a community is developed and women gain strength, through their talk.[11]

Here, shoes and clothing are elements of familiarity but also become poetic puzzles that seem almost secondary to the texts and stories that they contain and support—poems charted in space and time. These articles of women's clothing become metaphorical vessels, like the human body, for memory, history, and presence, and thus foreshadow some of HeavyShield's later works such as *body of land*, 2002.

In 2004, HeavyShield's installation *blood* was exhibited at the Southern Alberta Art Gallery in Lethbridge. For HeavyShield, *blood* evokes ancestry, ties to family, language and land, women's experiences of birth and renewal, the smell of a freshly killed deer, and memories associated with many lifetimes, past and future. The Blackfoot story of Blood Clot, who returned to the people

the memories so that they could sing and dance again is recalled in *blood*. As a member of the Blood tribe of the Kainai nation, the word also defines HeavyShield's personal history.

> kuto'iis
> came to be in an instant
> full force
> from a blood clot
> each time she tells his story
> she marks off
> on one hand
> just how small his origin
> with the three middle fingers tucked in
> she moves her thumb to touch the crease
> below the tip of the pinkie[12]

Comprised of hundreds of small knotted balls of cloth affixed to a large wall, all painted monochromatically in ochre red, *kuto'iis* becomes a personal and lyrical map that relates in formal structure and pattern to *body of land*. Each knot signifies a blood clot, marking a remembrance and perhaps a commemoration. The repetitive and ritualized acts that formed these knots are a re-collection of stories, the sounds of language and song, of home.

The installation titled *kuto'iis* introduces the viewer to the wide range of HeavyShield's approaches, techniques, and materials. Taken together, the diverse elements reveal a non-linear consciousness that cannot separate past from the present, the real from the imagined, and the communal from the personal.

HeavyShield's work at times moves from addressing relationships with the land to that with rivers and other bodies of water. Both of HeavyShield's childhood homes in southern Alberta

30. Faye HeavyShield, *mark*, 2008. Graphite on mylar.

inscribed with her thoughts while creating the large digital print collage, *old man is a river*, exhibited as part of the Alberta Biennial in 2005. For *this is not a river*, 2005, HeavyShield's process of writing replicates the flow of the river. The reductive contrasts elicited in the phrases such as "this is not my sister this is a river; this is not an etching this is grass" open the mind to shifting frames of reference.

Language—Blackfoot and English—has always been an integral part of HeavyShield's art practice. At times, she writes about a work as part of the process of refining its concept and physicality. At other times, she may write a poem or story that may not necessarily develop a specific idea but may, instead, capture various threads of the artist's thoughts during this creative process.

HeavyShield further developed her "river project" during two residencies in New Brunswick. In 2004, she created *camouflage* using stones and twigs from the Old Man River that carried photocopied images of the river environment and text from a Blackfoot dictionary. She placed the stones on the shore of the St. Croix River and left them to their fate; three weeks later, most had been scattered or carried away by the tides. Created on the occasion of the 400th anniversary of Samuel de Champlain's arrival at this site, subtle and minimal, this work addresses themes of transplantation and exchange. HeavyShield recalls that, of the small group of settlers who intended to settle here, only a handful survived the winter.

The next year, HeavyShield created

were near rivers: the Oldman River and to the west, the Belly River. As a young child, she and her siblings played in the Oldman.[13]

Through digital images, writing and drawing, my time spent with rivers—their influence on our bodies and our histories—has been recorded and re-played. And through travels, this engagement with the idea of place and its texture has come to be site-specific.[14]

In 2004, HeavyShield began examining these rivers, creating black and white photocopies from digital photographs. One side of the lozenge-shaped work featured detailed images of prairie grass in encaustic. The other side was

31. Faye HeavyShield, *this is not a river*, 2005. Paint, graphite text on digital prints.

rock paper river, an installation of 600 small paper boats in colors that ranged from mossy green to sky blue and deep red. The individual boats were configured into a pattern on the floor with soft lighting that created shadows beside each vessel and enhanced the impression that the boats floated on a shimmering body of water. The boats carried photographs of the land, water, and shorelines around Fredericton, New Brunswick. Similar to *body of land* and other works, these installations address shifting perspectives on oppositional notions such as distance and closeness, similarity, individuality, and difference. In an adjoining room, she documented the role of the camera, calling attention to the places that nurtured her artistic process. HeavyShield often includes process-related information in her installations, considering it a complementary approach to the presentation of her work.

In 2007 and 2008, HeavyShield studied the collections of beadwork made by the Blood people that are housed at the Canadian Museum of Civilization, the Glenbow Museum, and the Royal Ontario Museum. She reflected upon museum classification systems of objects such as bags, gloves, and dresses, which were identified only by small catalogue tags and stored in rows of drawers or on shelves. But she also imagined the people, mostly women, who had made these objects, people to whom she and her family are related by history and language.

. . . it is easy to transpose tradition with history as being finite, at times maybe even mistaken for the past . . . while tradition exists as a part of history, it is also an ongoing process. We build on tradition each time we discover something new about the old, whenever a part of the past is reactivated.[15]

The delicately hand-beaded *hours*, 2007, represents a book—beautifully devoid of text. We are reminded of the repetitive nature of women's work, the quality of meditation, and the joys of conversation while working with others. The book carries the memory of all the gestures and thoughts that have been laid upon it, whose own story continues to be active and engaging; intimate and limitless.

The time spent beading, as suggested by the title of my work, is a tie to this ordinariness, as is the scale—which is reminiscent of a small missal or diary. My work *hours* is not proffering anything in the way of historical reference—except for my own touch.[16]

Extending the idea of categorization, identification, and identity, *mark*, 2008, is composed of rows of small opalescent forms, made from mylar and covered in graphite finger smudges, are arranged

Faye HeavyShield, *camouflage*, 2004. Rocks and twigs, digital photography.

Faye HeavyShield, *rock paper river*, 2005. Paper, digital prints.

in a grid on the wall. From a distance, all the forms appear to be identical. A closer look reveals that HeavyShield has traced and cut each figure individually. The lightness of the material causes each form to assert its own physicality as it curls up on itself and then flutters in the air stirred up by passing viewers. Here again, HeavyShield invites meditation upon form and movement, upon distance and closeness, upon perspective and imagination.

Although HeavyShield is inspired by memories and history, her art reflects her life as a contemporary artist. She addresses the complexities of her imagination and the diverse concepts and processes that are important to her. Her works revitalize contemporary sculpture, infused, as they are, with a fluid timelessness. Ultimately, HeavyShield's identity and community offer the freedom in which to create her art, on her own terms and in her own time—in the blood. ■

1 Conversation with the artist, June 4, 2009.

2 Editor's note: Faye HeavyShield lowercases the titles of all her works.

3 Lee-Ann Martin, *Mapping Our Territories* (Banff, Alberta: Walter Phillips Gallery, 2002), 8.

4 Lee-Ann Martin, *In My Lifetime* (Quebec City, Quebec: Musee National des Beaux-Arts du Quebec, 2005), 59.

5 Margaret Archuleta, *The 4th Biennial Native American Fine Arts Invitational* (Phoenix, Arizona: The Heard Museum, 1992), n.p.

6 www.kelownaartgallery.com/2002/faye_heavy shield.htm. Accessed April 30, 2009.

7 Artist's statement, *New Territories: 350/500 Years After* (Montreal: Vision Planetaire, 1992), III.

8 Ibid.

9 Press release, "Into the Garden of Angels," The Power Plant, Toronto, Ontario, June 1994.

10 Mary-Beth Laviolette, *An Alberta Art Chronicle: Adventures in Recent and Contemporary Art* (Altitude Publishing, 2006), 326.

11 Vera Lemecha, *Faye HeavyShield: venus as torpedo* (Regina, Saskatchewan: Dunlop Art Gallery, 1995), 4–6.

12 Faye HeavyShield, *Faye HeavyShield: blood* (Lethbridge, Alberta: Southern Alberta Art Gallery, 2004), 41.

13 Video interview with the artist, Canadian Museum of Civilization, Gatineau, Quebec, 2007.

14 Artist's statement, axeneo7, Gatineau, Quebec, 2008.

15 Artist's statement, *Tracing History: Presenting the Unpresentable* (Calgary, Alberta: The Glenbow Museum, 2008), 136.

16 Candice Hopkins and Kerry Swanson, *Shapeshifters, Time Travellers and Storytellers* (Toronto, Ontario: Royal Ontario Museum, 2007), 18.

Wendy Red Star (CROW) BEAUTY AND THE BLOW-UP BEAST

POLLY NORDSTRAND
(*Hopi/Norwegian*)

Princesses have always held the magical power to tame the wild beasts and enchant the vast forest. This is especially true in Los Angeles. When not prevailing over the evil forces that try to squelch their dazzle, princesses charm into perfect harmony all the creatures that surround them. Wendy Red Star assumes these captivating powers in the *Four Seasons* series. We can almost hear Snow White's voice echoing off the mountain side, or Pocahontas proclaiming, "You can paint with all the colors of the wind." It's so lovely that the scenes are almost breathtaking . . . if it weren't for the cardboard cut-outs and the blow-up beasts.

Instead of the sweet delight of a fairyland, we feel the disorientation of Alice in Wonderland. What at first seems to be a sparkling potpourri, disintegrates into a hodgepodge of fakery. Creases in the 1970s photo mural backdrop dissect the sky and land. Each meticulously placed bloom and leaf opposes the abrasive Astro-turf floor covering it lies on. At the center of each season sits Wendy Red Star, contradicting the saccharine surroundings.

Red Star's experience in moving to Los Angeles to pursue a M.F.A. in sculpture left her feeling isolated. "I was struck by the lack of natural environment in the city of Los Angeles and I was also lonely for home. I decided to go searching for something familiar, so I took a trip to the Los Angeles County Natural History Museum to look at the Native American section. I saw one of my Crow ancestor's moccasins on display in a glass case. Seeing my ancestor's moccasin in the glass case felt very odd and misplaced."[1] Her response to

the museum display is not unique among Indian people. As an artist, she was drawn to the museum objects for creative sustenance, but instead the experience reinforced the cold disconnect that she felt as a result of her relocation from Montana to southern California. In creating these self portraits for the *Four Seasons* series, she hoped to communicate the feelings of longing and not belonging.

Like so many Disney princesses, Red Star exudes a taming effect on the animals in *Spring*. The fawn, rabbit, and coyote are as comfortable with each other as they are with her. The ridiculousness of this camaraderie could only exist in a Disney movie . . . or a natural history museum diorama. Red Star enjoys using humor in her art to blur the tension of some of her themes. Tuscarora scholar Jolene Rickard described the meeting place of the wise and comical as the "terrain of the absurd."[2] Red Star's absurd terrain, chock-full of plastic flowers, floral foam, and packing peanuts, sets a stage for us to consider the circumstances of the woman at the center of it all. Did she stray too far into the museum and become trapped behind the window glass? Or is she willingly a part of the charade—making the most of make-believe?

Although the distortion of her carefully constructed dioramas exaggerates the artificial and mocks the hyper-real replicas in museums, Red Star is careful with her own presence in the unnatural landscapes. Dressed in an elk-tooth trade-wool dress and thoroughly adorned with beautifully beaded accessories, she seeks to unmistakably identify

34c. Wendy Red Star, *Spring* (detail) (from *Four Seasons* series), 2006. Color print.

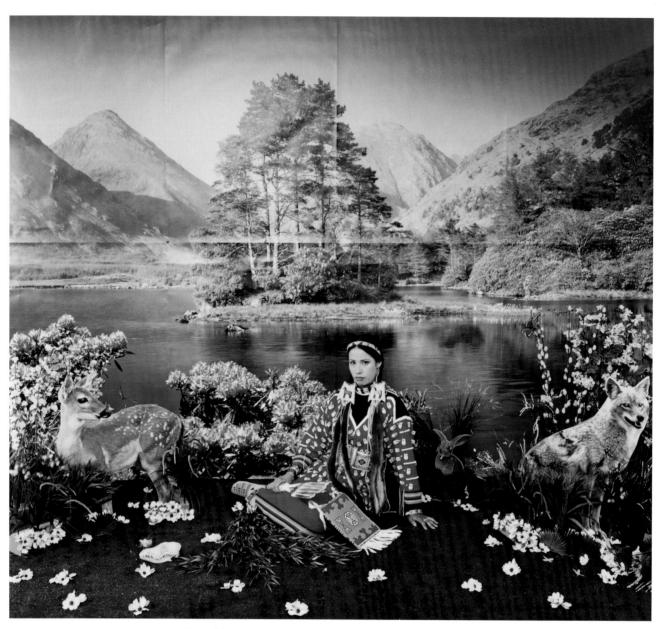

34c. Wendy Red Star, *Spring* (from *Four Seasons* series), 2006. Color print.

herself as a Crow woman. "In my work, I make sure that I am extremely culturally specific and only deal with my tribe."[3] She urges the viewer to see her genuine self as belonging to a specific culture group, not through the generalizing lens of Hollywood movies. Had she placed herself among taxidermies as a true museum diorama would have, she would have affirmed the stereotyped

Indian. By selecting the cardboard deer and silk butterflies as her window dressing, Red Star emphasizes the accuracy of her own self-portrait.

In *Indian Summer*, she strikes a pose, rendering the scene not so much a museum diorama as an early twentieth-century Indian "princess" postcard. The angular and semi-dramatic pose is a familiar posture in the depiction of

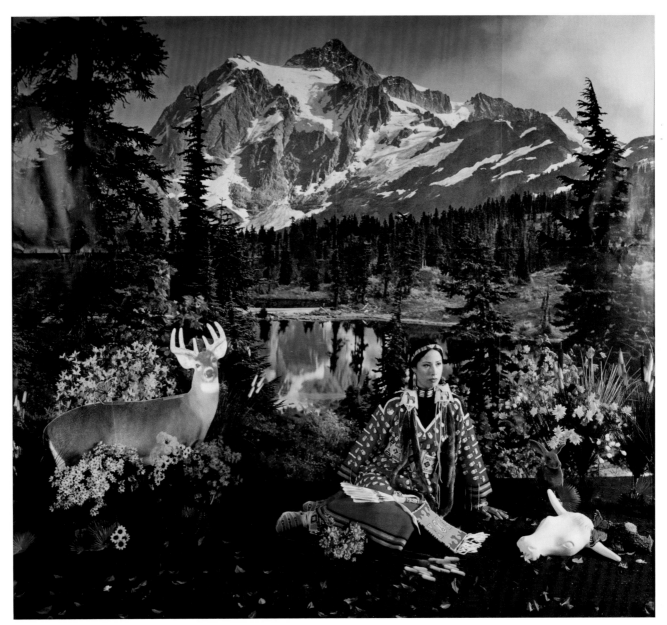

34b. Wendy Red Star, *Indian Summer* (from *Four Seasons* series), 2006. Color print.

fictitious Indian women. Postcard photographs used similar poses to romanticize anachronistic views of Indian life. "In contrast to the mundane look of frontal poses, the more contrived poses lent an aura of grandeur. The subjects became ennobling and transcendent figures whose images could be mythologized and severed from their true historical place."[4] Red Star makes no

attempt to place herself in time or place with any specificity. Like the postcard photographs that "convey depersonalized and ahistorical messages,"[5] Red Star asserts through her photographs that her own life experience has taken on aspects of the sterility of the postcard scene. The female subjects of postcard images were anonymous and tribeless. Red Star's identity was eroding in

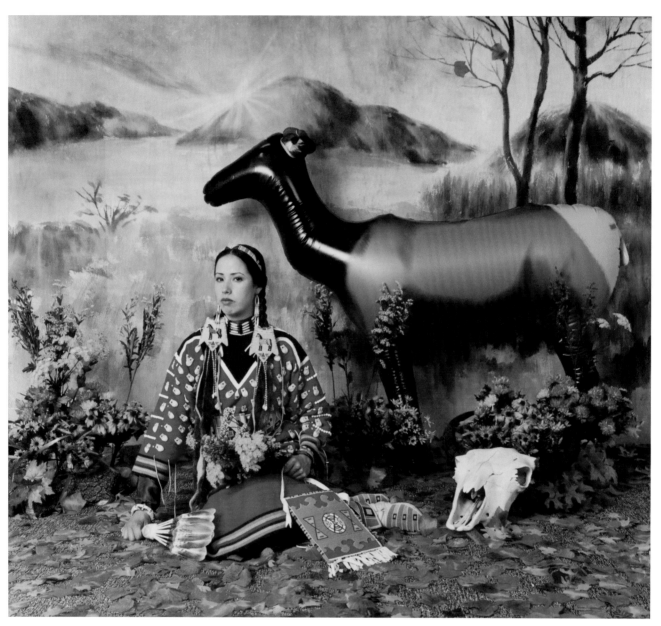

34a. Wendy Red Star, *Fall* (from *Four Seasons* series), 2006. Color print.

L.A., where people were more familiar with Pan-Indianism than her own Crow identity.

In the case of the "princess" image and other stereotyped portraits of Indian women, the public does not read the pictures in terms of meanings intrinsic to the subject's own experience and culture. Rather, the public interprets them in terms of pat stereotypes, which reinforce and play to popular notions of Indian people as spectacles and objects, whose existence and authenticity reside only in the myths that the visual media, including the postcard and Hollywood film, have created. One result of this kind of image making, of course, is that it denies any real understanding of the concrete experience and conditions of Indian women in the past or present.[6]

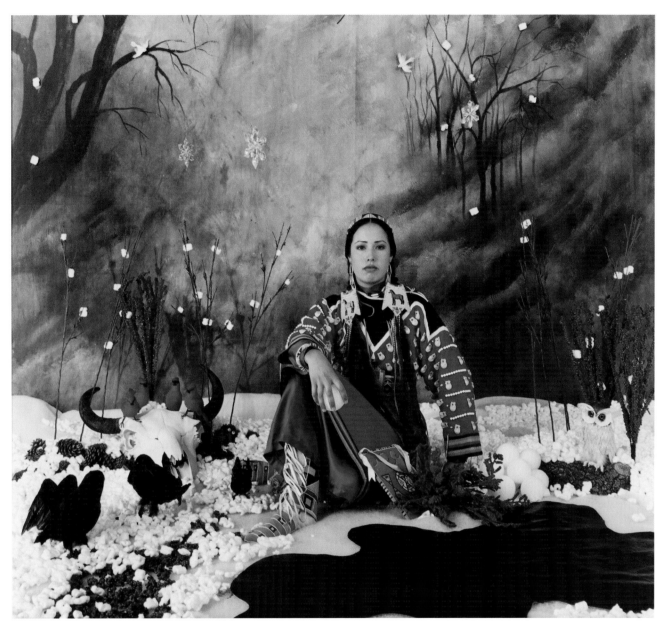

34d. Wendy Red Star, *Winter* (from *Four Seasons* series), 2006. Color print.

The next portrait in the series, *Fall*, realizes the full effect of fake. The shinny blow-up elk stands conspicuously against the poorly painted backdrop of an autumn meadow scene. The overall appearance of the image is not too far from a Sears studio portrait that you might find in many Indian living rooms. Red Star's proud posture widens the gap between the concocted stage and herself. The blur of the painting and the clearly unreal animal recede from her presence. And with it diminishes the viewer's certainty about the interrelatedness of the Indian beauty and the beast. Photos do not lie? The fakeness of the entire series undermines the reality we think we know.

At the same time, another beast has reared its head—the bison skull at her

32. Wendy Red Star, *Fancy Shawl Project*, 2009. Installation; five shawls and dresses, DVD.

32a. Wendy Red Star, *Basketball Hoops*, 2009. Fabric, ribbon.

feet. The skull might be one found in the halls of the museum as a specimen, but in Red Star's world, it might be used in a ceremonial context to facilitate the real connection between individuals and animals. Red Star reveals the moment she found herself in the museum looking at the Crow objects, expecting to find comfort, but instead finding a chill. Stepping into the museum, she had actually entered the absurd terrain. Like Alice, Red Star had to defend her own understanding of what should have been familiar from her life on the Crow reservation, whereas in the museum it was reduced to a strange imitation. Bringing her own cultural understanding to the

experience, she realizes the limitations of the museum world, and wants to communicate to us (or at least to Los Angeles) the delusion that is taking place. The skull stands with her to correct the misunderstandings about Indian people perpetuated by popular culture.

Each new scene moves us closer to Red Star immerging from the fantasy place into the real world. Although she sits in a pile of packing peanuts in *Winter*, her casual pose indicates that she is not a willing participant in the deception. She stares out at us, playfully armed with a Styrofoam snowball. The pretense of an Indian princess has vanished. We see a person. And Red

32b. Wendy Red Star, *Housing*, 2009. Fabric, ribbon.

Star wants us to see a living Crow woman.

If we are left wondering what images we can use to replace our blotted-out stereotypes, Red Star provides the alternatives in her Fancy Shawl Project.[7] In designing the five shawls, she provides answers to her questions of belonging. Shawls create for Indian women a shell of comfort and beauty. Decorated with designs of all possibilities—abstract, figurative, and floral—they can be conservatively plain or borderline gaudy. The fancy shawl has become more and more elaborate to be used in exuberant fancy-dance powwow competitions. Fabric and color choices help exaggerate the twirling and prancing movements of the dancers with flashing impact. Long elegant fringe expands the dancer into a flowing whirl of energy. And in this project, the shawls are like the ruby slippers returning us to Red Star's home.

Over a multiple year period, Red Star documents the things in the everyday life of the Crow reservation. The things she sees on her summer drives are houses, cars, dogs, sweat lodges, tipi poles, and basketball hoops. Some of these might be common to lots of other places, but these have been transformed by their users/owners into "Rez." Red Star describes her art work as an invitation "to confront and acknowledge a not so romantic view of indigenous

32c. Wendy Red Star, *Rez Cars*,
2009. Fabric, ribbon.

culture." The visual record that she
creates of her reservation is not
intended to be a romantic revision, but
a direct look at the place. Her valuing
this contemporary culture and place
shines through in her imagery—despite
what might be a lacking in picturesque
qualities.

Using shawls as the basis for her new
exploration, Red Star began designing
them using source images that she
found in books. Although her shawls
will eventually be transformed into can-
vases for her rez images, she maintains
the process used in making fancy
shawls and intends for them to be used
as dance outfits. A group of students
will wear them to perform a team

dance at the Chemawa Indian School
in Salem, Oregon, near where she is an
adjunct professor of art at Portland
State University. She plans to film the
performance to create a DVD presenta-
tion of the shawls in motion. The
strong colors and bold layout of each
shawl panel helps convince those famil-
iar with dance shawls of their function.
From a distance, they will read in the
dance performance like typical dance
costumes. The unusual layering of the
photos over the graphic appliqué is
what will draw viewers into the story.
While the shawls' compositions are
important in telling her story, the
intention to use them in dance trans-
forms each panel into a sculpture and

Above: 32d. Wendy Red Star, *Rez Dogs*, 2009. Fabric, ribbon. Below: 32e. Wendy Red Star, *Sweat Lodge*, 2009. Fabric, ribbon.

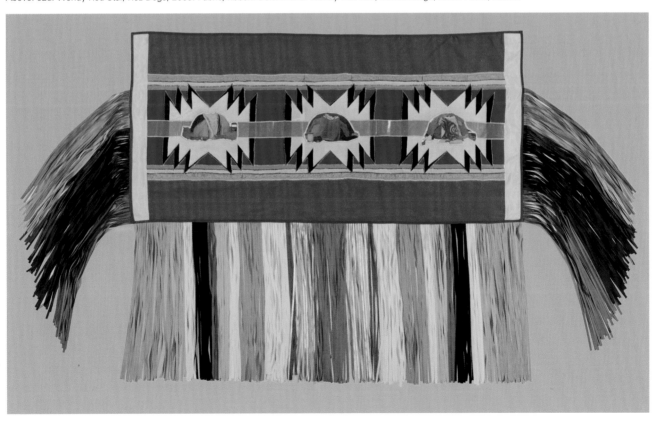

33. Wendy Red Star, *Found Photographs* (details), 2009. Mixed media.

the grouping into a performance piece. Whereas "traditional" shawls might be decorated with imagery related to creation stories or symbolic messaging that projects a more historic persona of the wearer, Red Star's shawls are unmistakably of the present.

Her frank look at the things that make up contemporary Crow life shoves us away from the romantic attitude we might have toward dance regalia. Powwow costumes—especially fancy dance outfits—have been transforming over the years from satin, feathers, and beads to lamé, CD reflectors, and sequins. Red Star takes

this natural progression and leaps ahead with it. She mediates our experience of Crow people in the twenty-first century by honoring her home with a healthy sense of humor. Instead of selecting a moment when the community might look its best, she finds the things that are there every day, the things people pass so often driving here and there that they probably don't notice them anymore. They are just a part of the landscape. Abandoned cars are abundant on many reservations. They were driven long and driven hard. Their bodies, broken and dismantled, speak of better days and useful futures. They race—or rest?—on horizontal stripes that seem to indicate they are doomed for collision. The scene reminds us of Plains pictorial drawings—horses rushing into battle at full force toward each other.

Taking this close look, Red Star made decisions about what she would share. She chose the government-designed and built houses over the tipi poles—which were also prevalent. *Housing*—as these structures are called—replaces the traditional tipi in this new worldview. Despite the architectural sameness of the HUD houses, Red Star notices that the owners have individualized their homes with color. As she focuses our attention to the details of each home by isolating the structure and removing the surroundings, she reveals the story of everyday life—satellite dish, bicycle, lawn mower, dangling holiday lights. Modern Indian life isn't so different from that of the rest of the world. Tourists will often travel to reservations with the expectation that life is what they know of it from history books, a sort of mystical camp life. They can be disappointed by the mundane community that they experience—it's too similar to their own lives.

Red Star makes an effort to present the spiritual aspect of her community

with a similar practicality using images of sweat lodges on another shawl. The radiating triangles around each lodge sets it apart from her treatment of the other images, but the details of her photography again help us understand her honest look at them as things—regardless of the activities that take place within them. We see in *Sweat Lodges* a plastic water cooler and a gas can. The sleeping bag is as sufficient to cover the door as the star quilt. Red Star intends us to look beyond the materials to see the purpose. The water used for the ceremony and recovery of the participants is no better or worse for being dispensed from the plastic barrel. This adaptation to modern life can be a shift that outsiders might consider a shrinking of the authentic Indians, but Red Star shows us without judgment what is actually happening. She checks our expectations to explain the equivalencies of life then and now. An historical photo might show a basket woven from grasses and branches, and now Indians might use a plastic Wal-mart bin, but the container still holds the same meaning in its purpose.

Some might argue that dogs have always held a special place in Plains Indian communities, but they have long been overshadowed by horses. *Rez Dogs* finally gives the pack its due. Unlike the photos in *Housings*, each dog highlighted on this shawl clearly indicated the huge variety on the reservation. Dogs of every size, shape, age, and temperament seem to be included. The scattered arrangement of the mutts and breed dogs implies the loose control reservation dogs enjoy. Storybooks might promote the close relationship Indians have with their "spirit" animal, and of course these would be bison, bear, or eagle. Red Star exposes her comical side by pointing out the more obvious daily companionship of the pup.

Unexpected imagery in this series is probably best displayed in *Basketball Hoops*. More artists are starting to show the importance of sports activities to Indian communities, so Red Star's inclusion of basketball shouldn't be much of a surprise. We've seen the prominence of basketball players in fiction such as Sherman Alexie's *The Lone Ranger and Tonto Fistfight in Heaven* for a long time now. Discussing this book and others, literature professor Peter Donahue described the status of ball players in this way: " . . . Indian basketball players have become the new tribal warriors, and in turn, the stories Indians tell one another about their basketball warriors have become the new tribal legends."[8] It makes perfect sense that Red Star would include the "new warrior" in her introduction to the twenty-first century Crow. Just as powwow outfit imagery might feature a Plains warrior with feathered headdress and rifle on horseback, it has also evolved to include themes of U.S. military status, university school colors, and even superheroes like Spiderman (although this might be limited to children's costumes). Red Star's *Basketball Hoops* supports all aspects of honoring the glory days—hers are on the court rather than the battlefield.

The glorification of basketball is not a recent development for Crow. In an article for *Sports Illustrated*, Gary Smith described Larry Pretty Weasel as "the legendary Crow player, some people